Flowers On Kaleidoscope

High Contrast Kaleidoscopic Photos
Of Flowers To Color

ERIKA S. CLARK

In memory of my mother who taught me
the joy of growing flowers and food.

Copyright © 2012 Erika S. Clark

All rights reserved.

ISBN: 1535384301
ISBN-13: 978-153584308

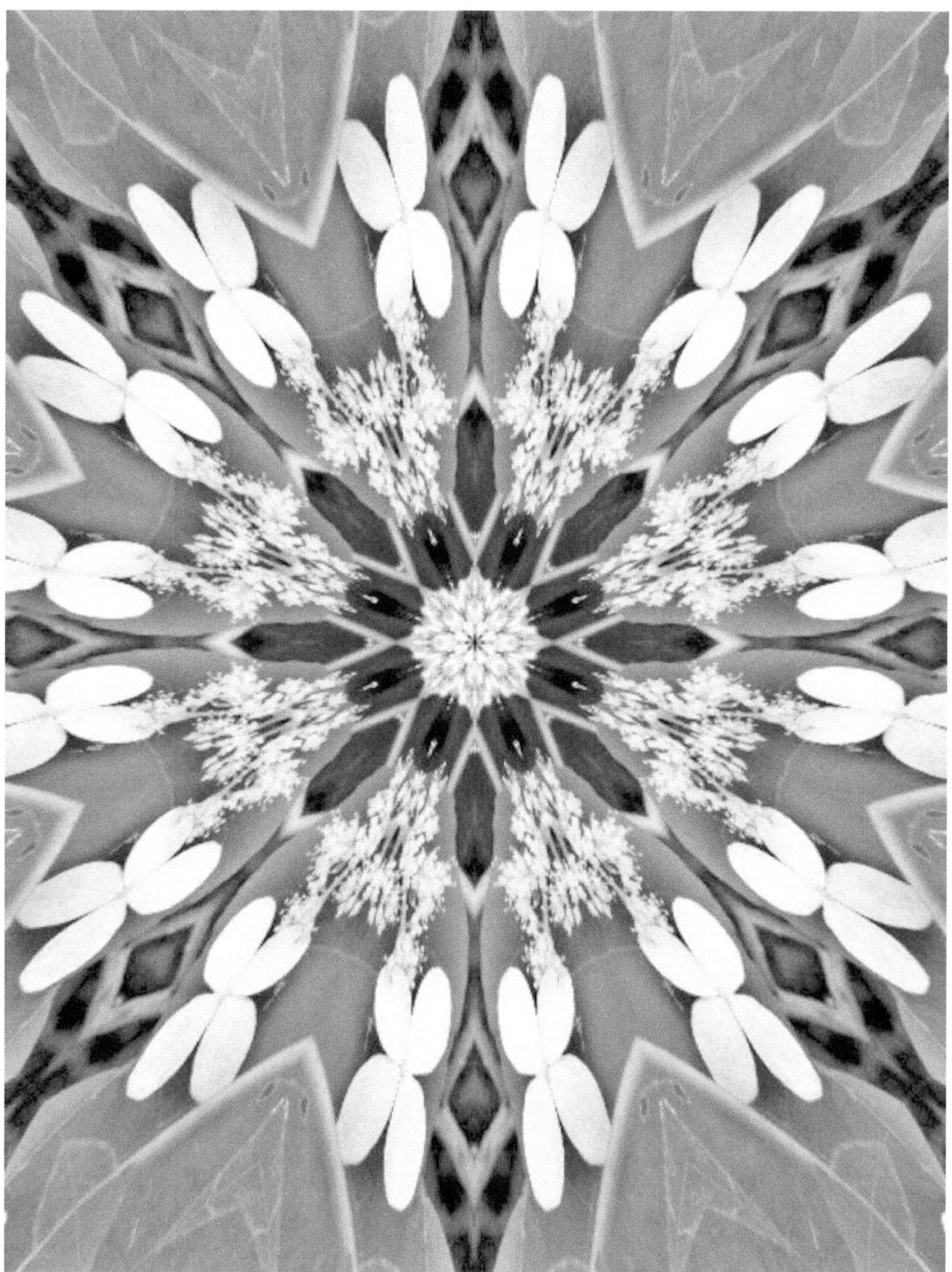

Hydrangea
Rainbow Falls, South Carolina

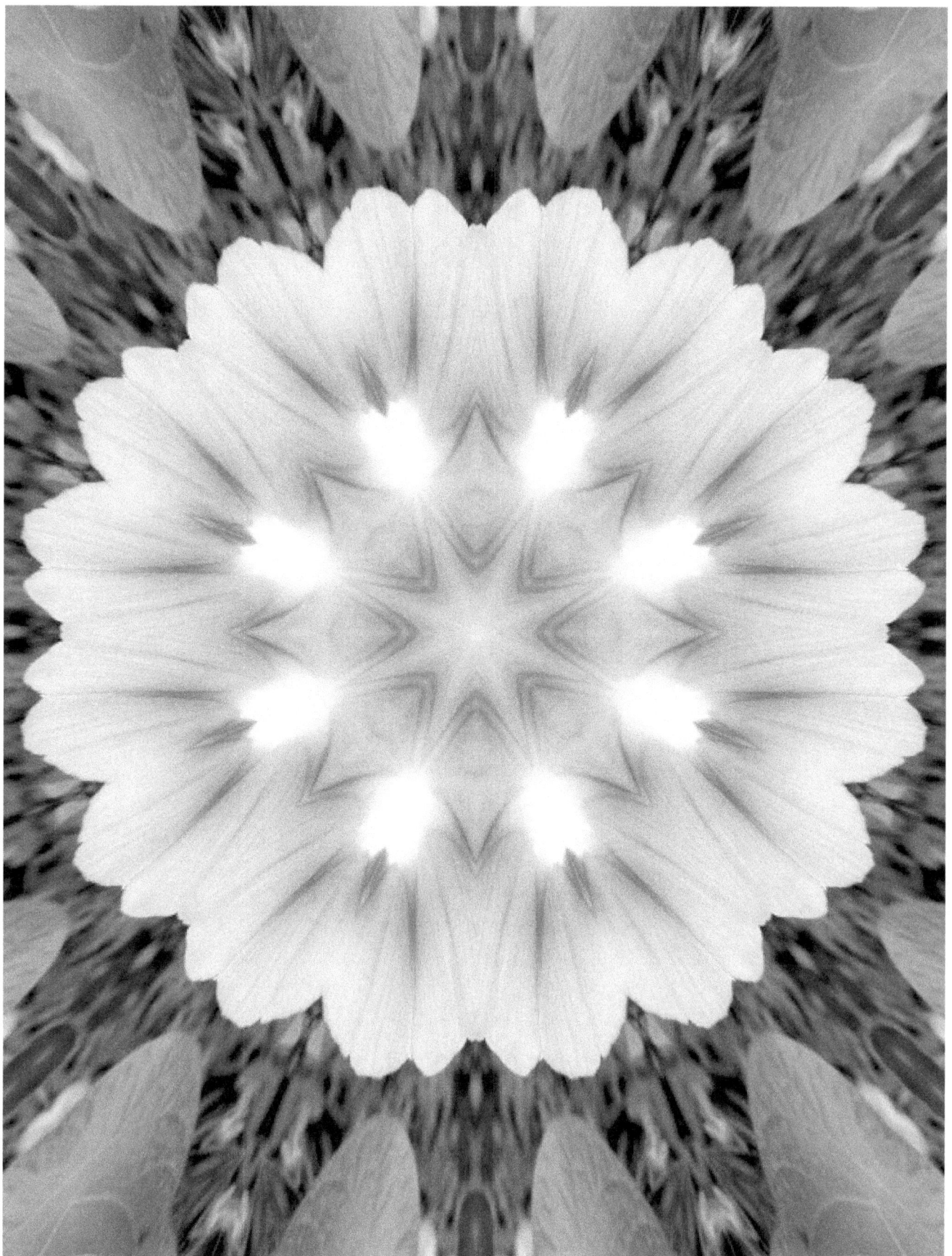

Petunias

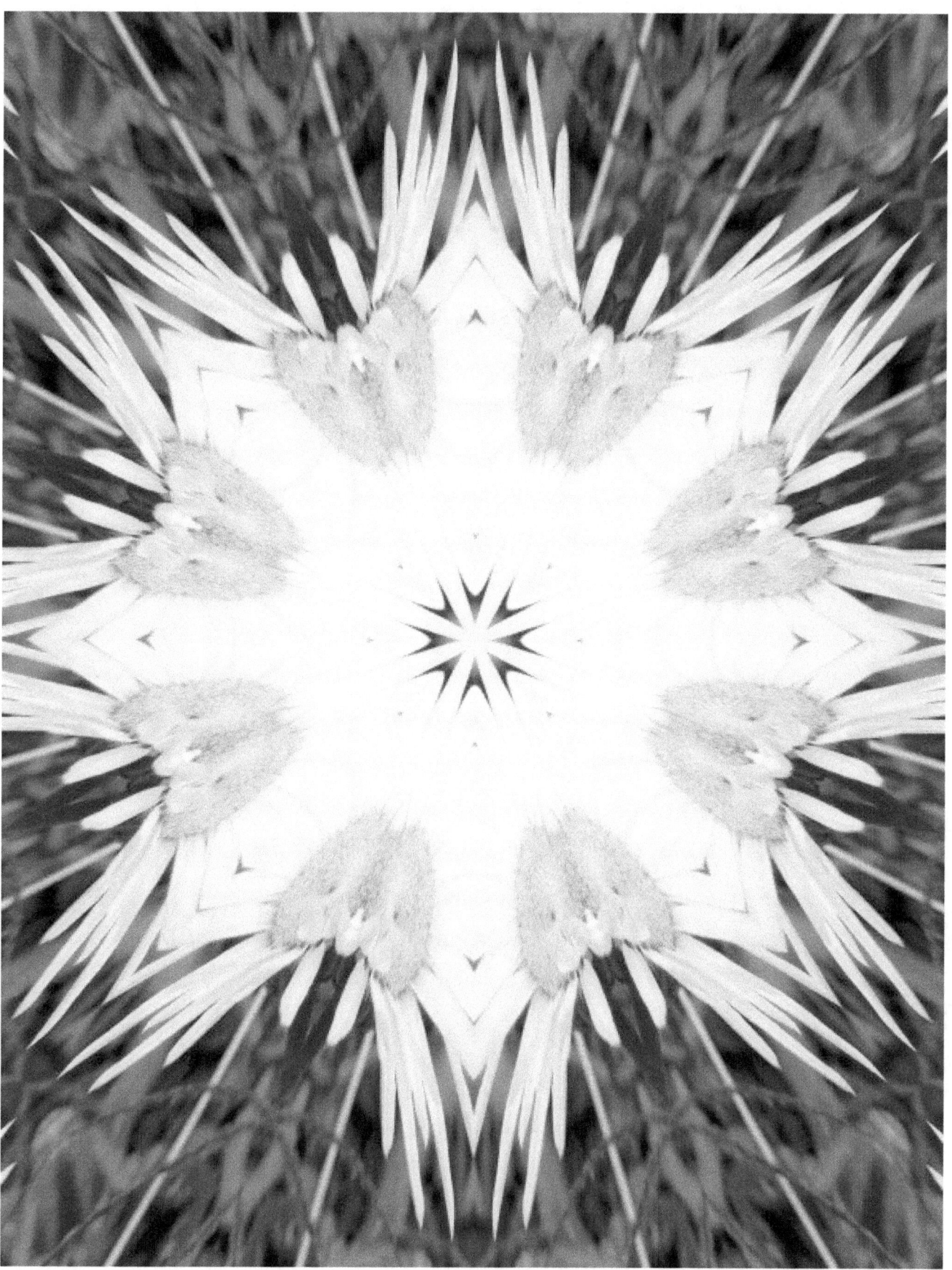

Shasta Daisy

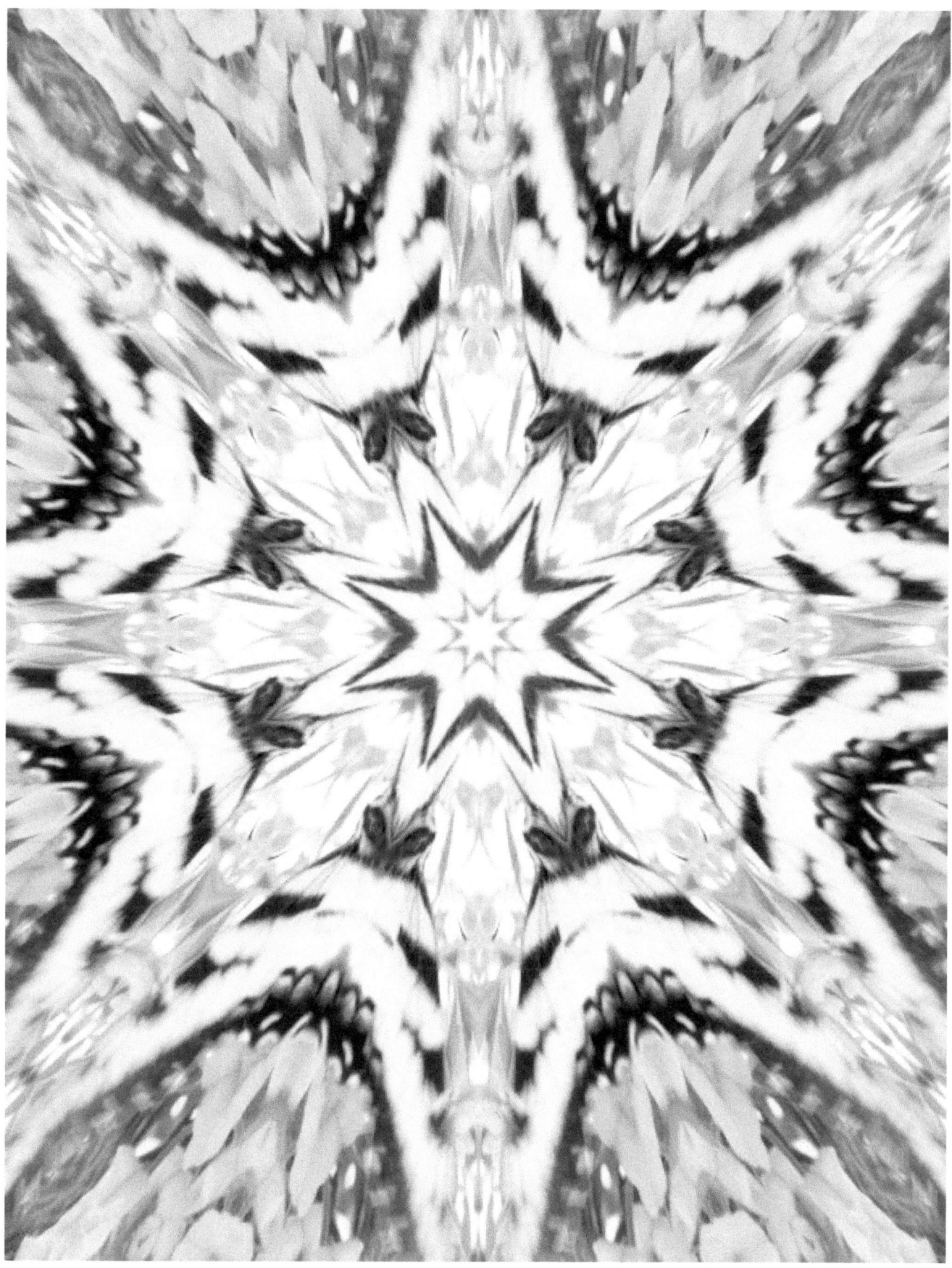

Forget-Me-Not

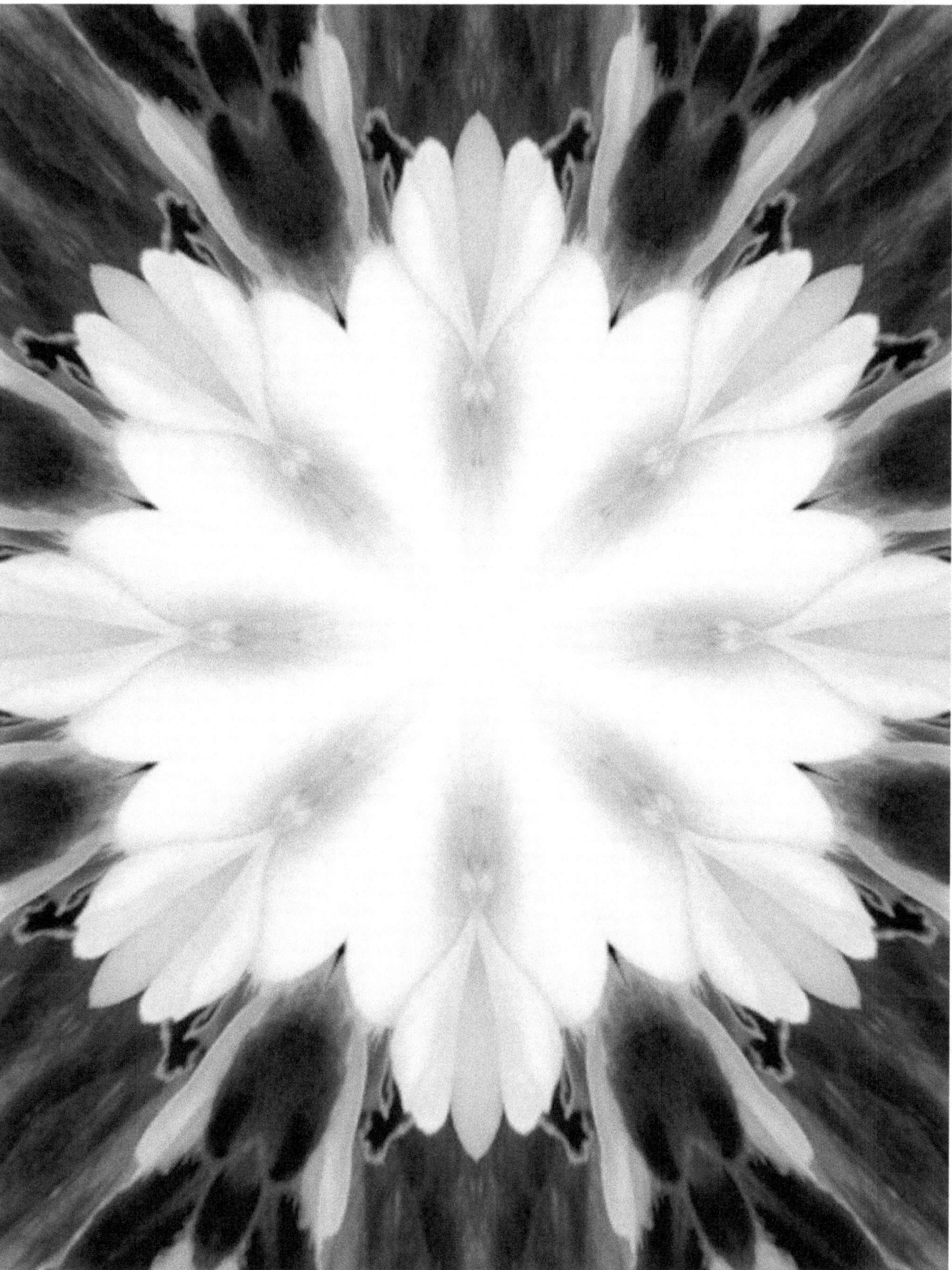

Begonia

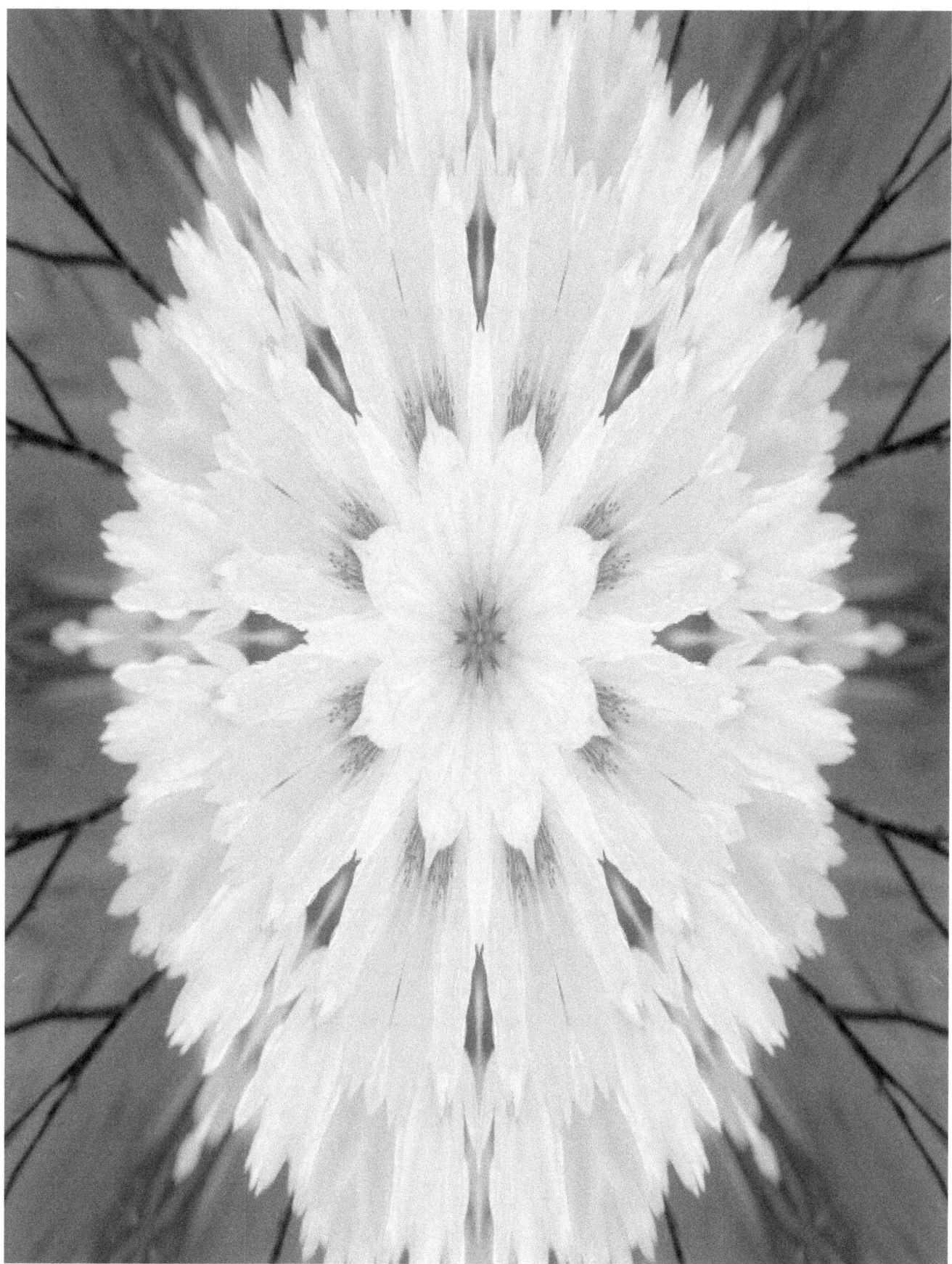

Cherry Blossoms

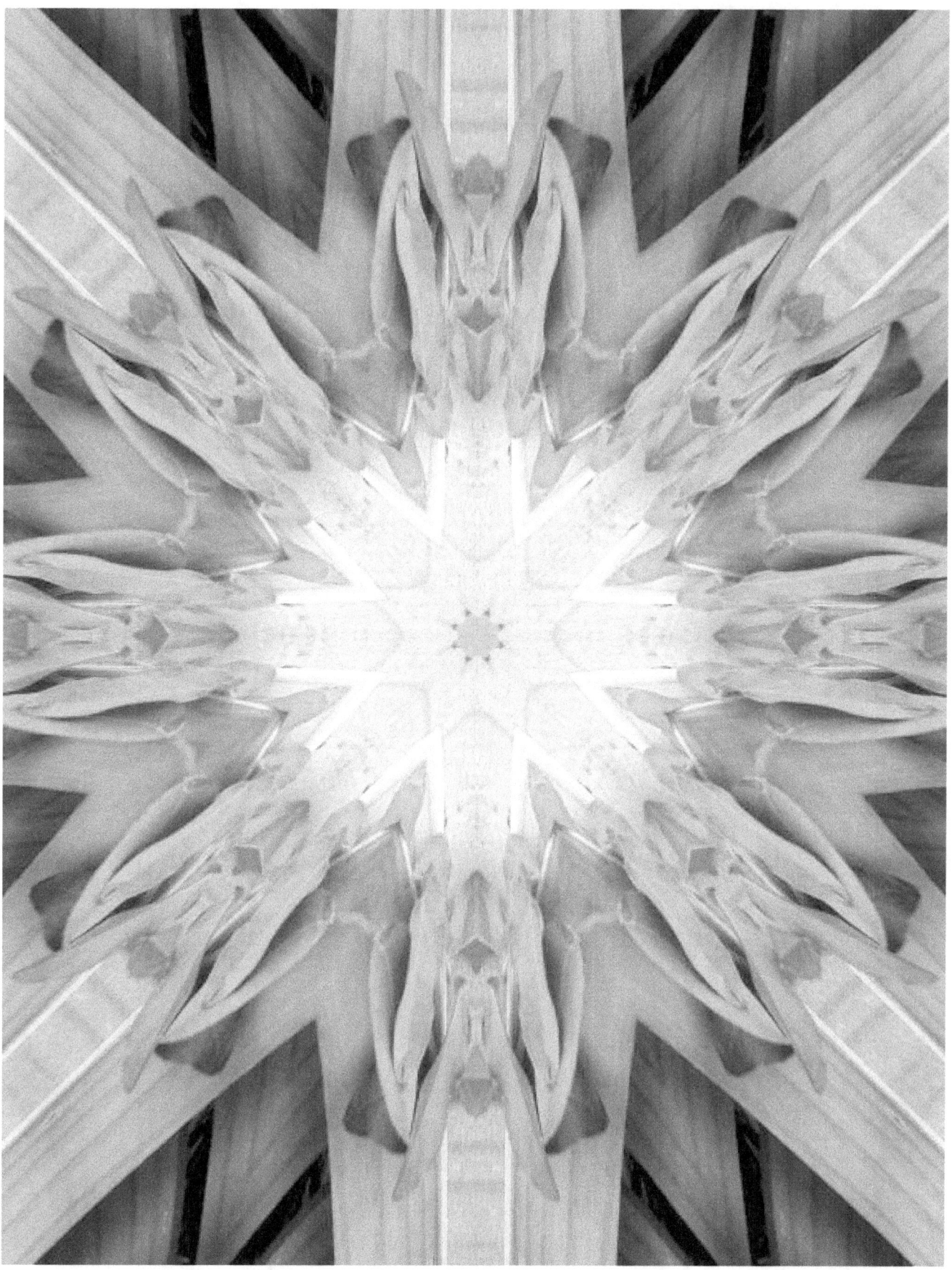

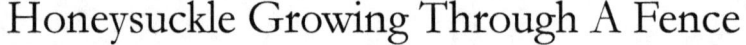
Honeysuckle Growing Through A Fence

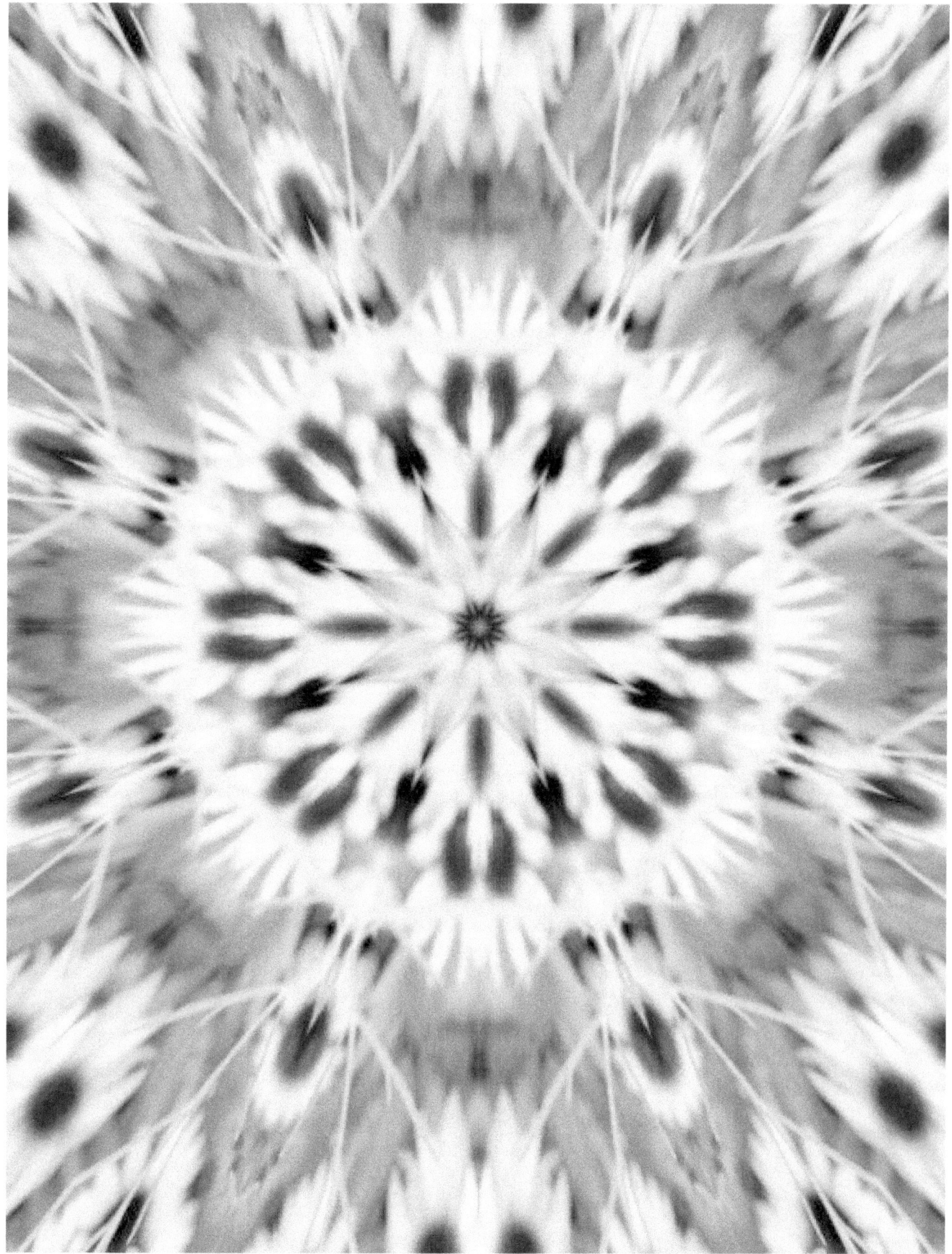

Cosmos

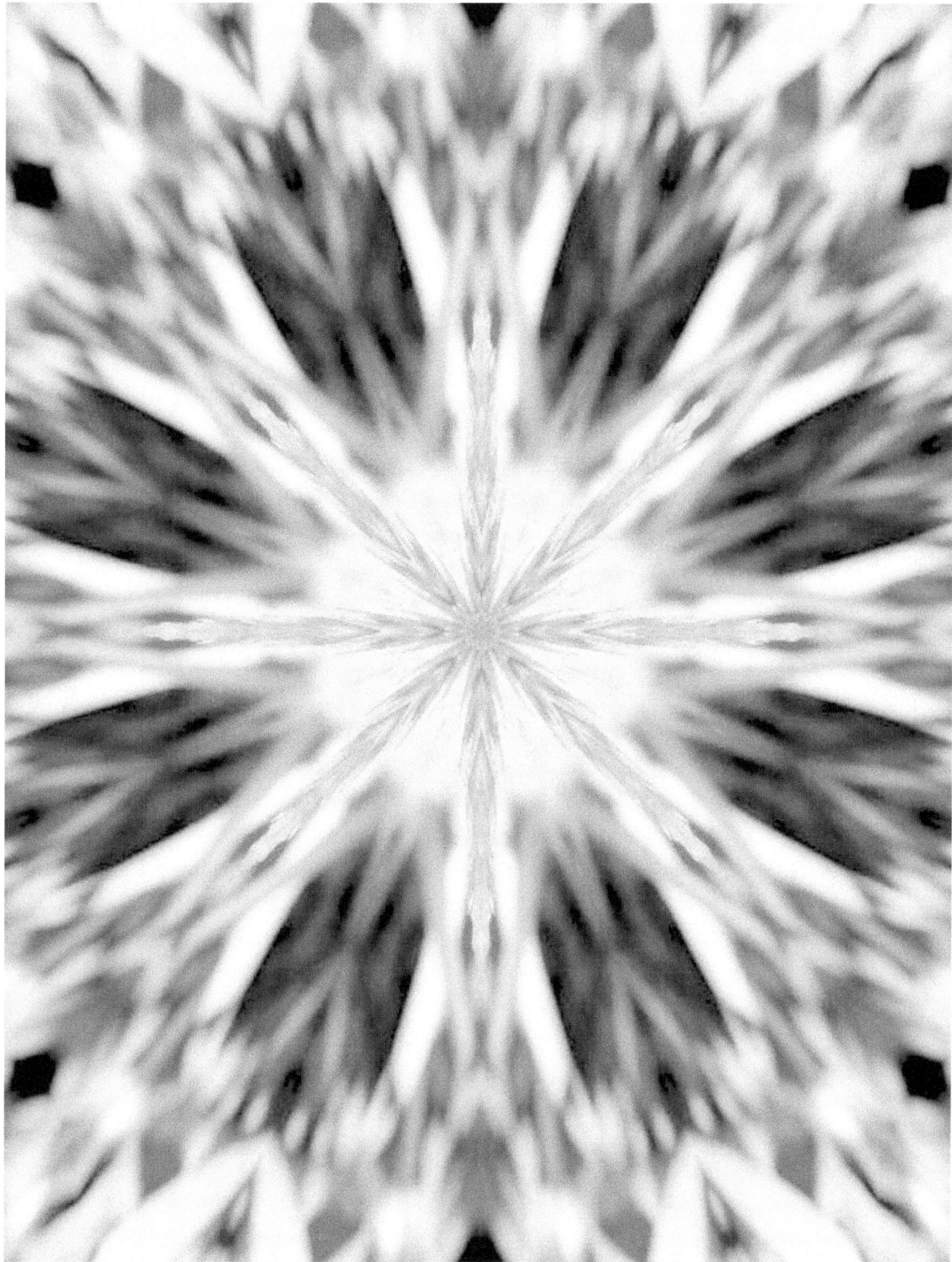

Amaranthus

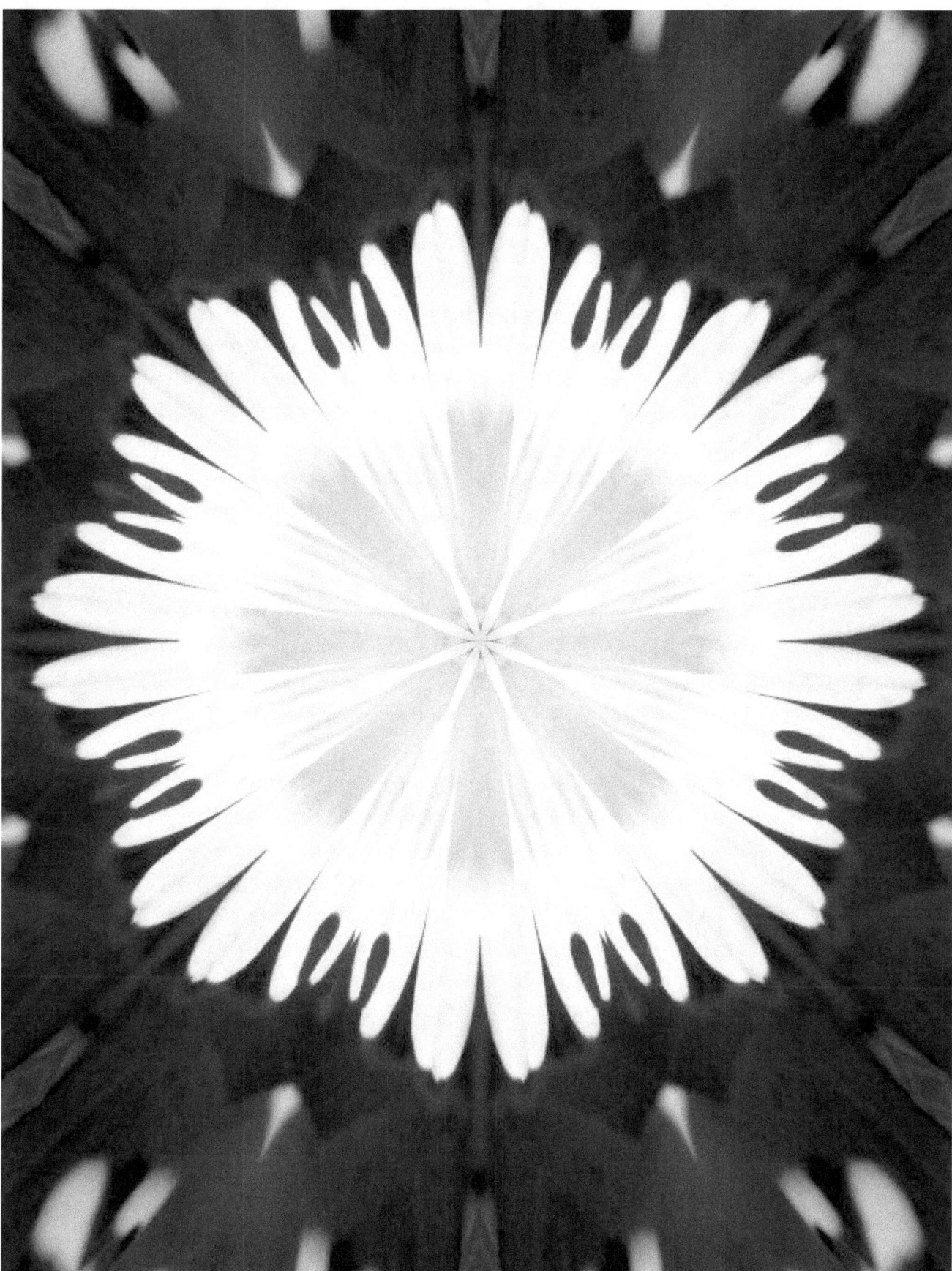

Zinnia with bee

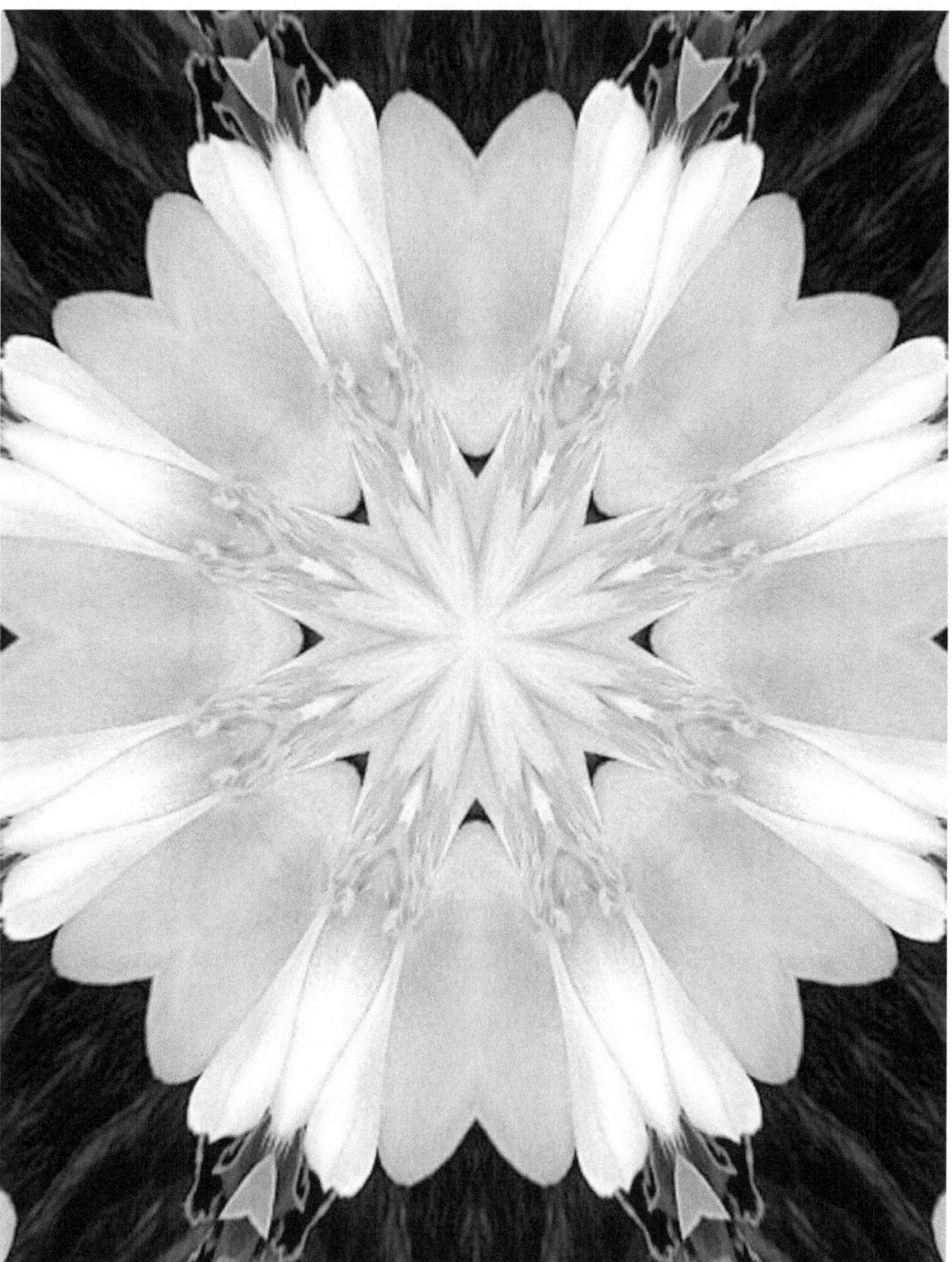

Begonia

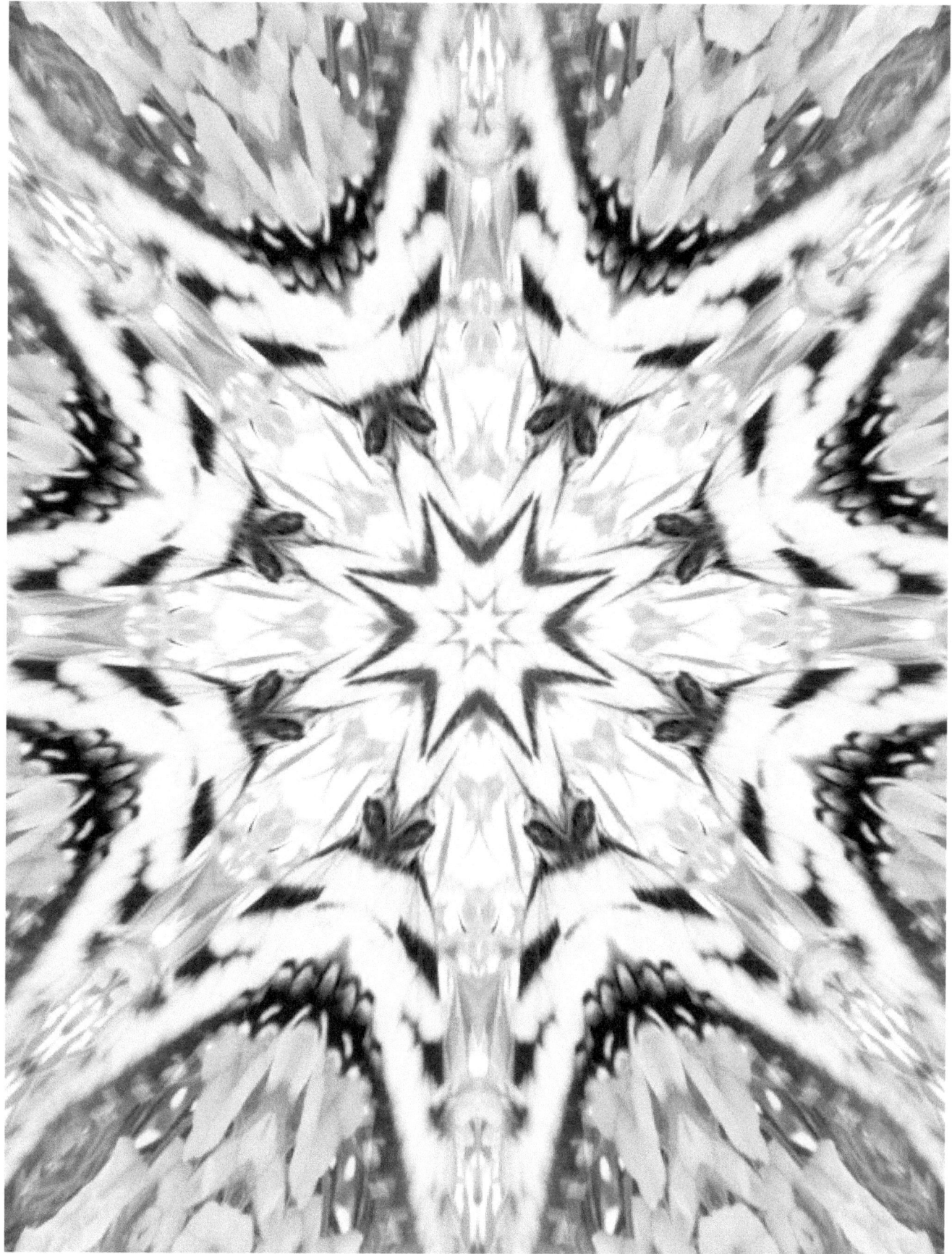

Petunia with butterfly

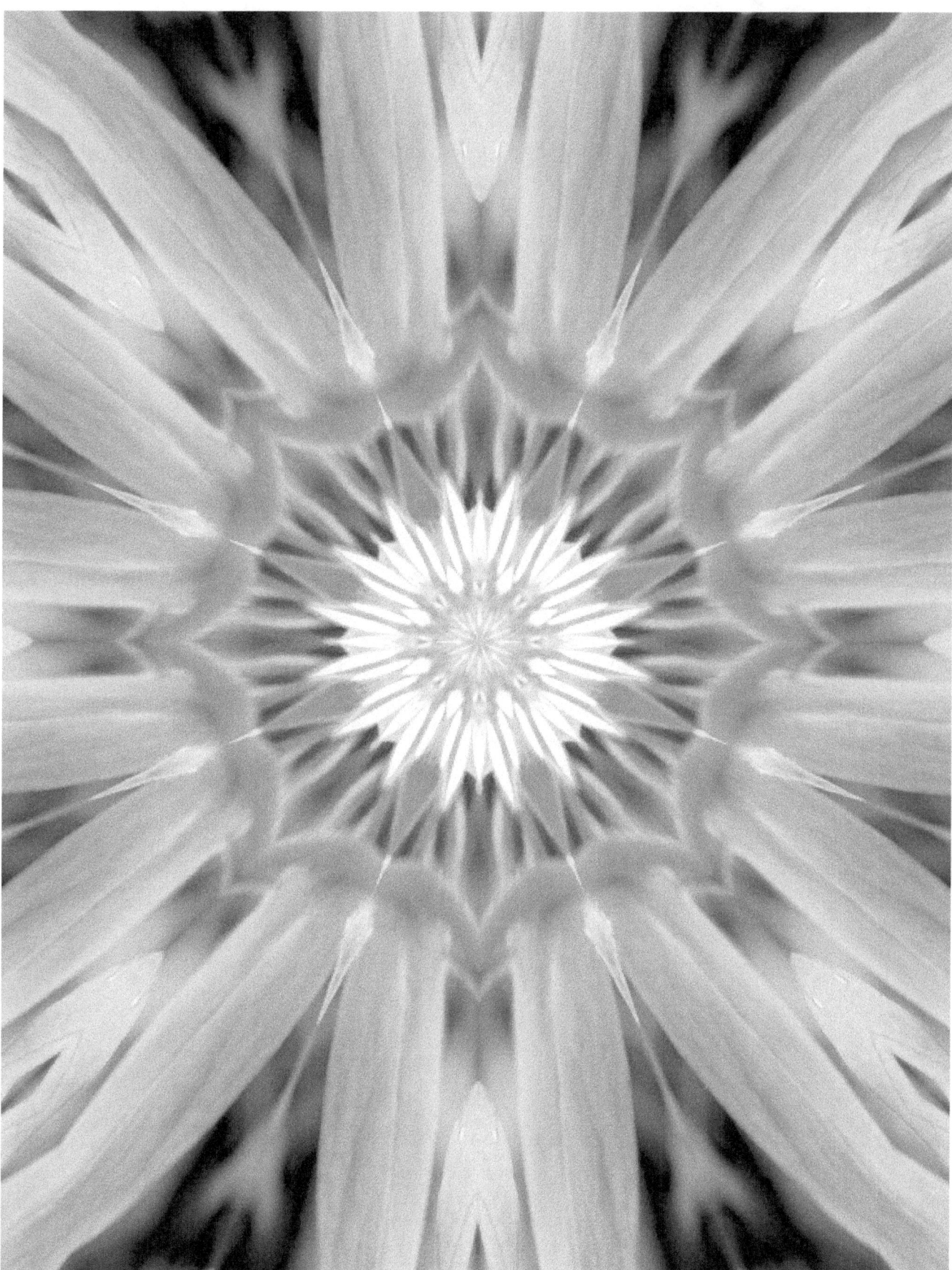

Chickweed

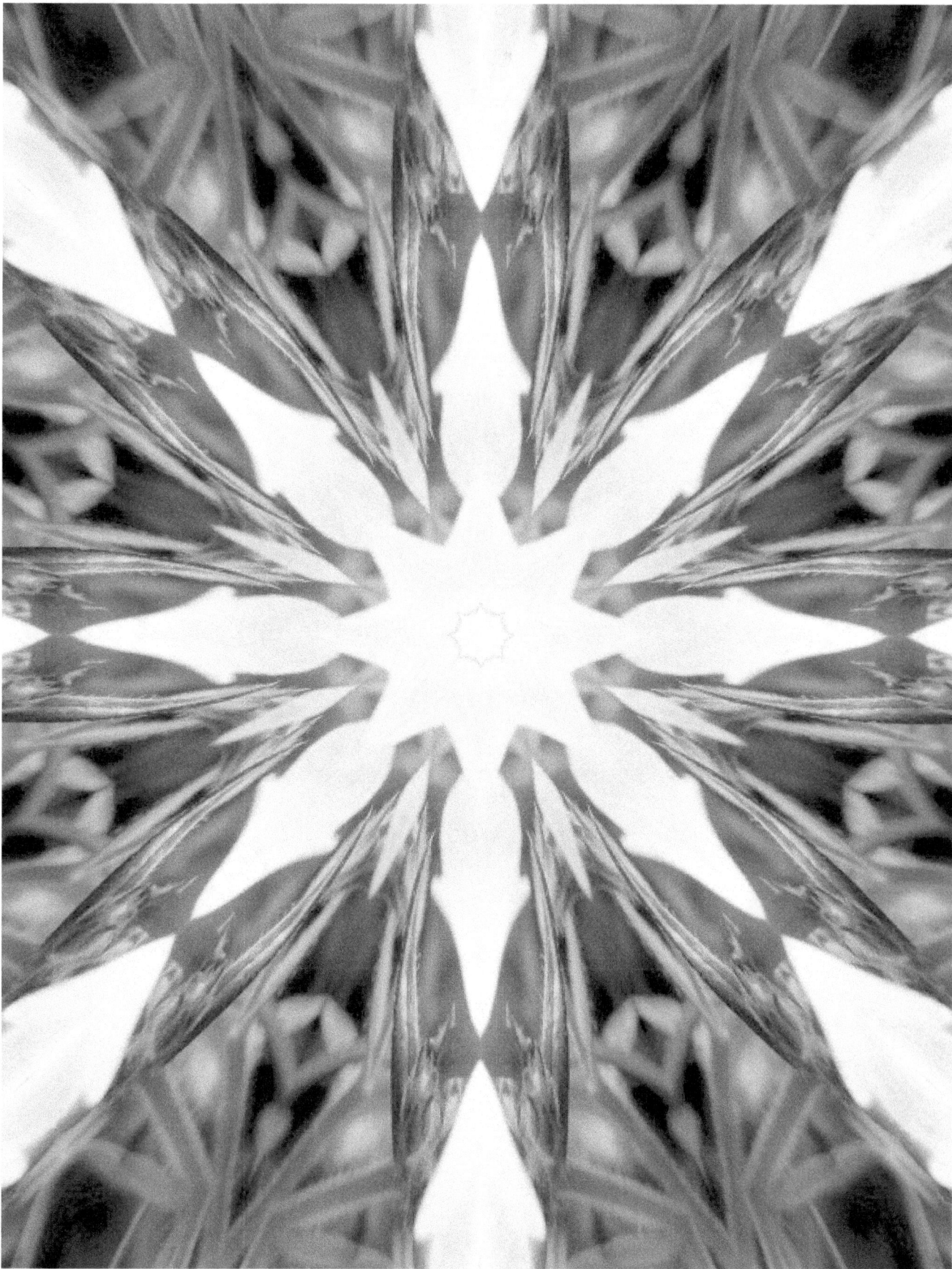

Phlox

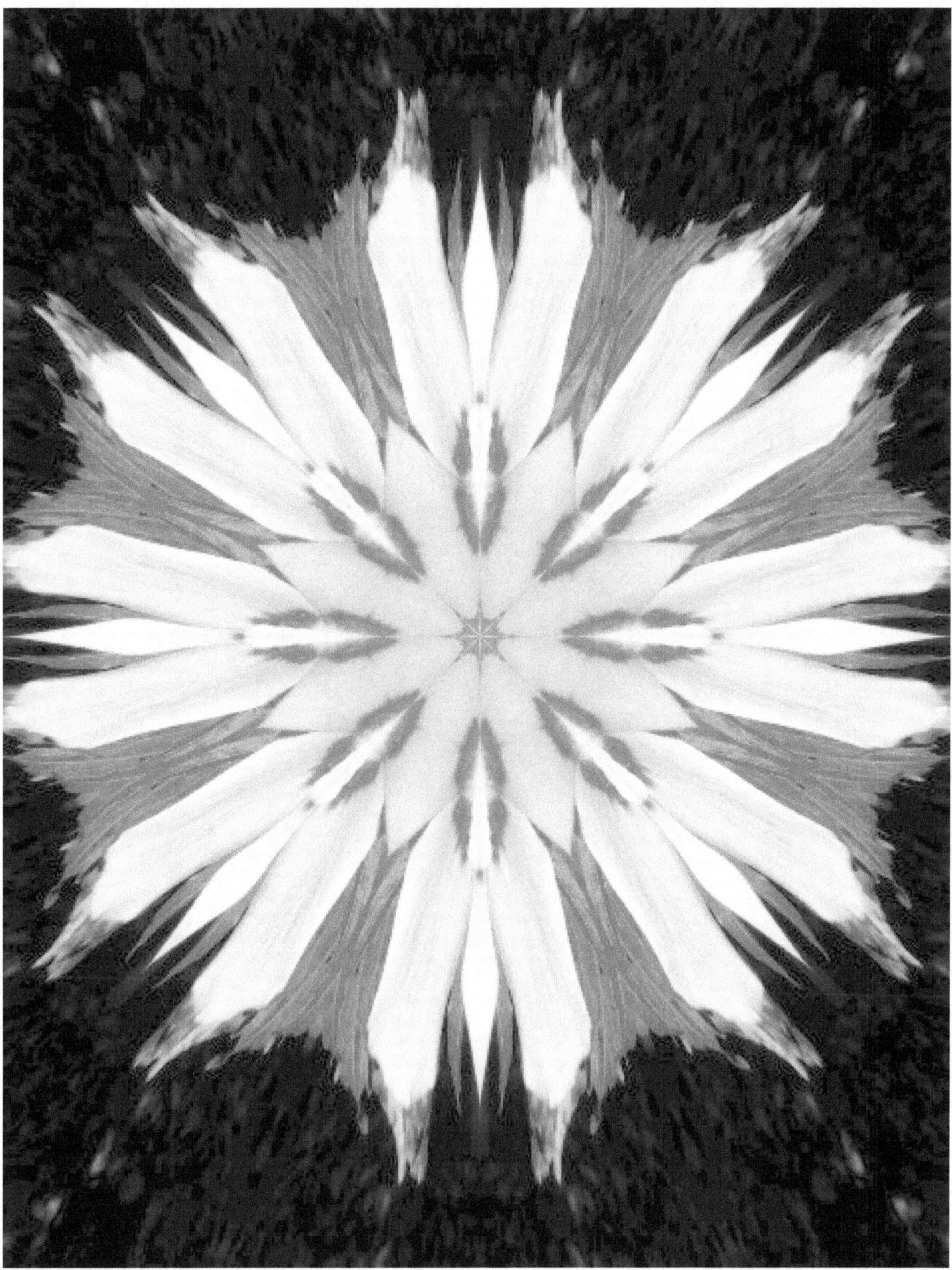

White Rose of Sharon

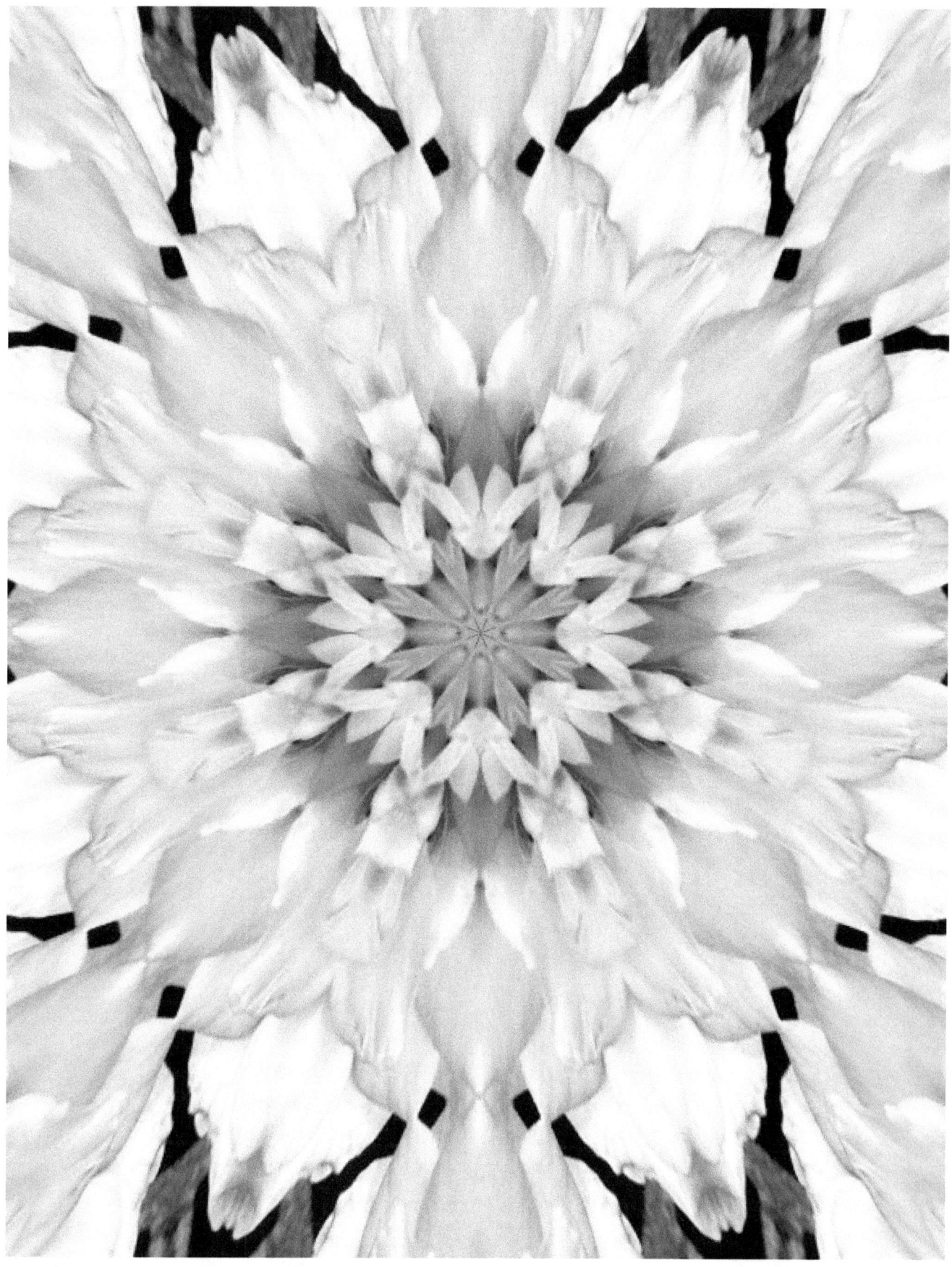

Roses

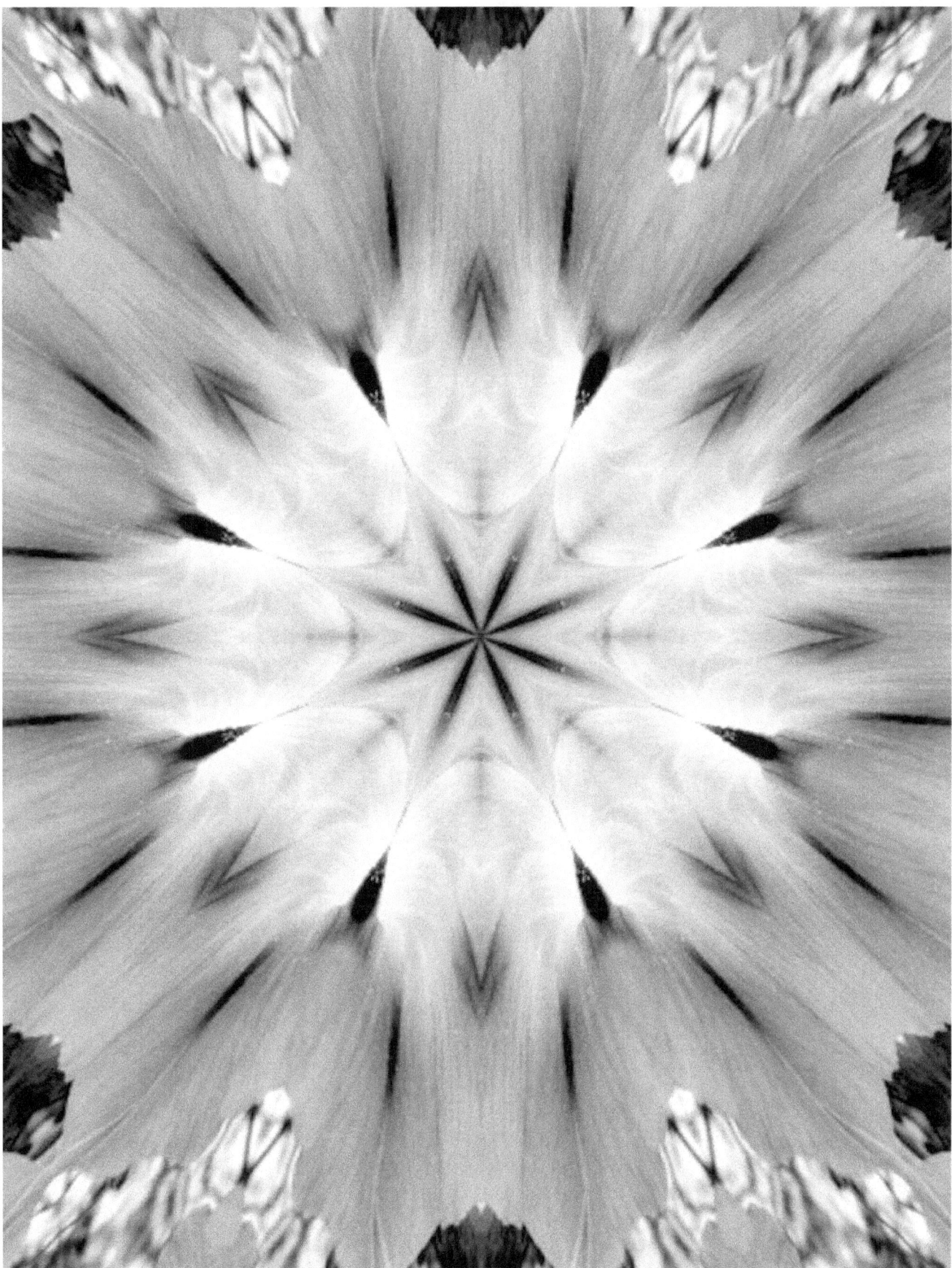

Morning Glory

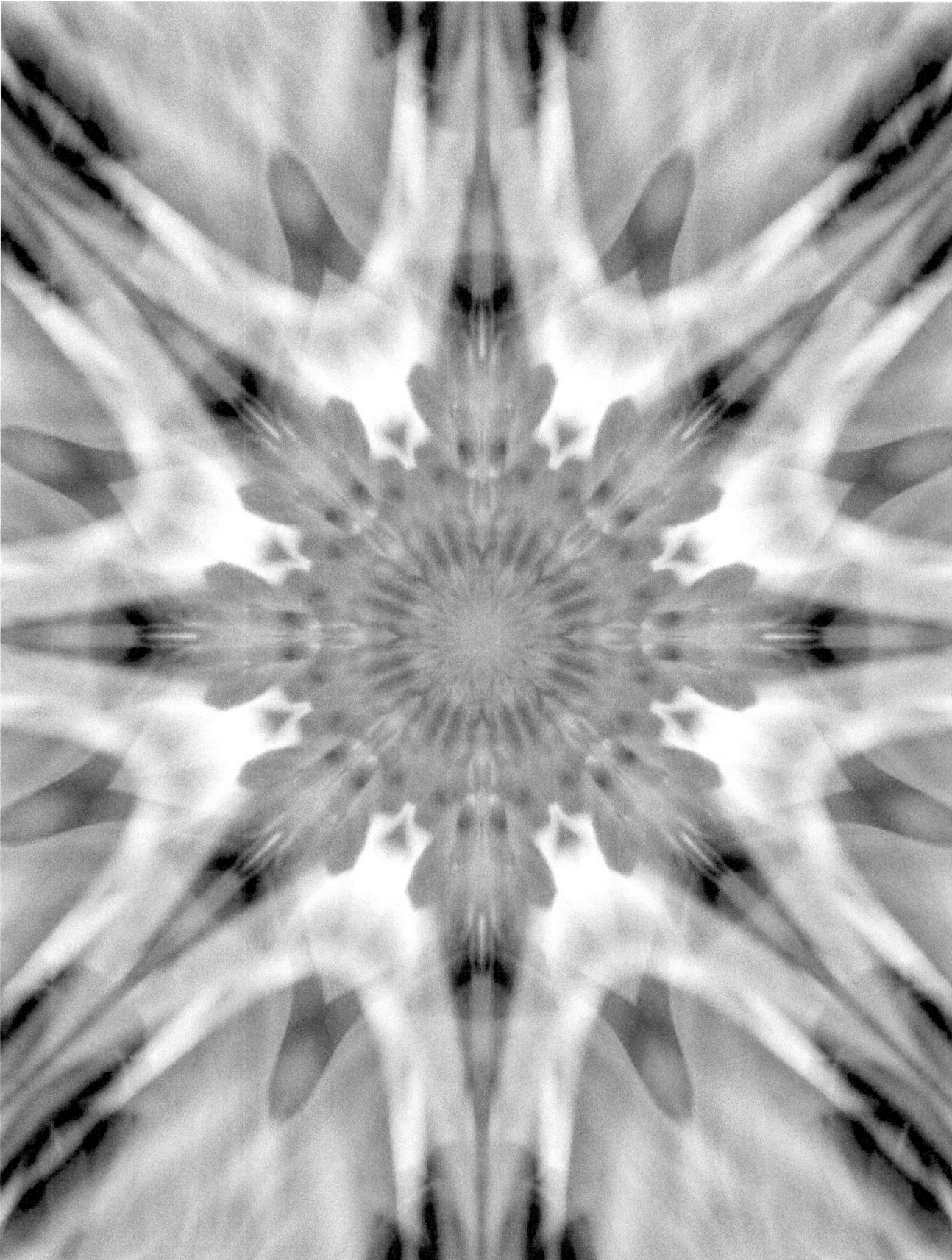

Monkey Grass

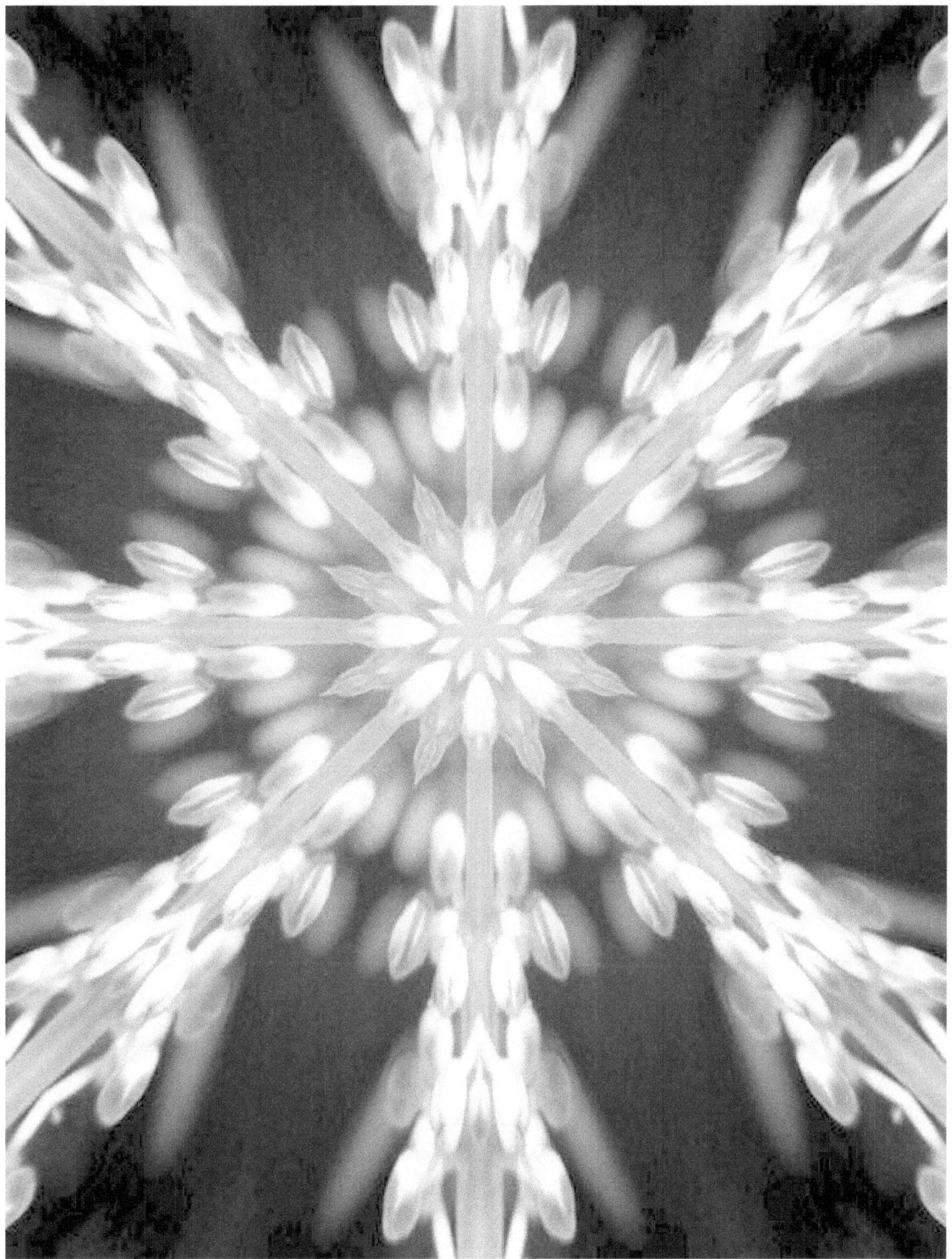

Monkey Grass

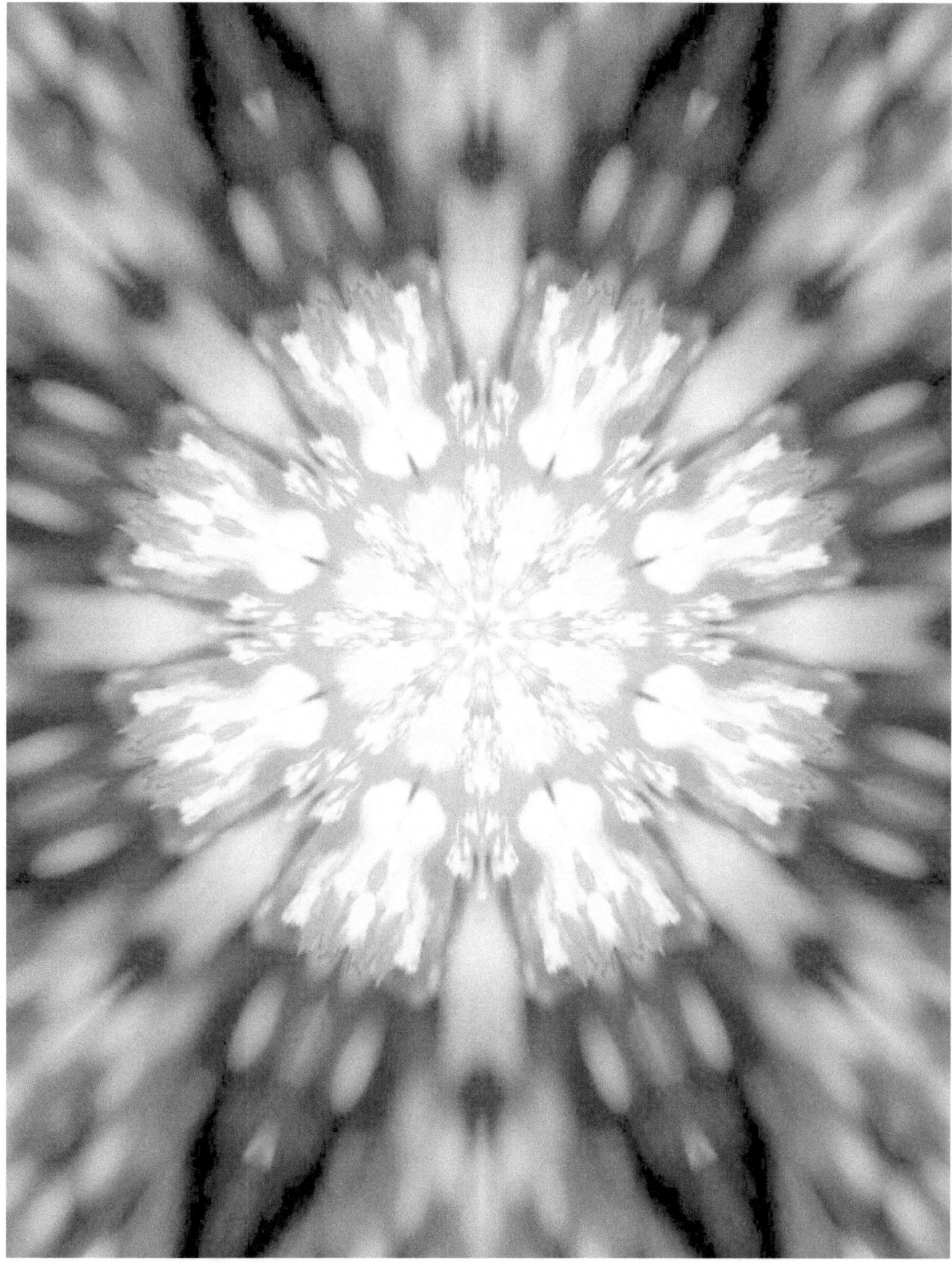

Myrtle

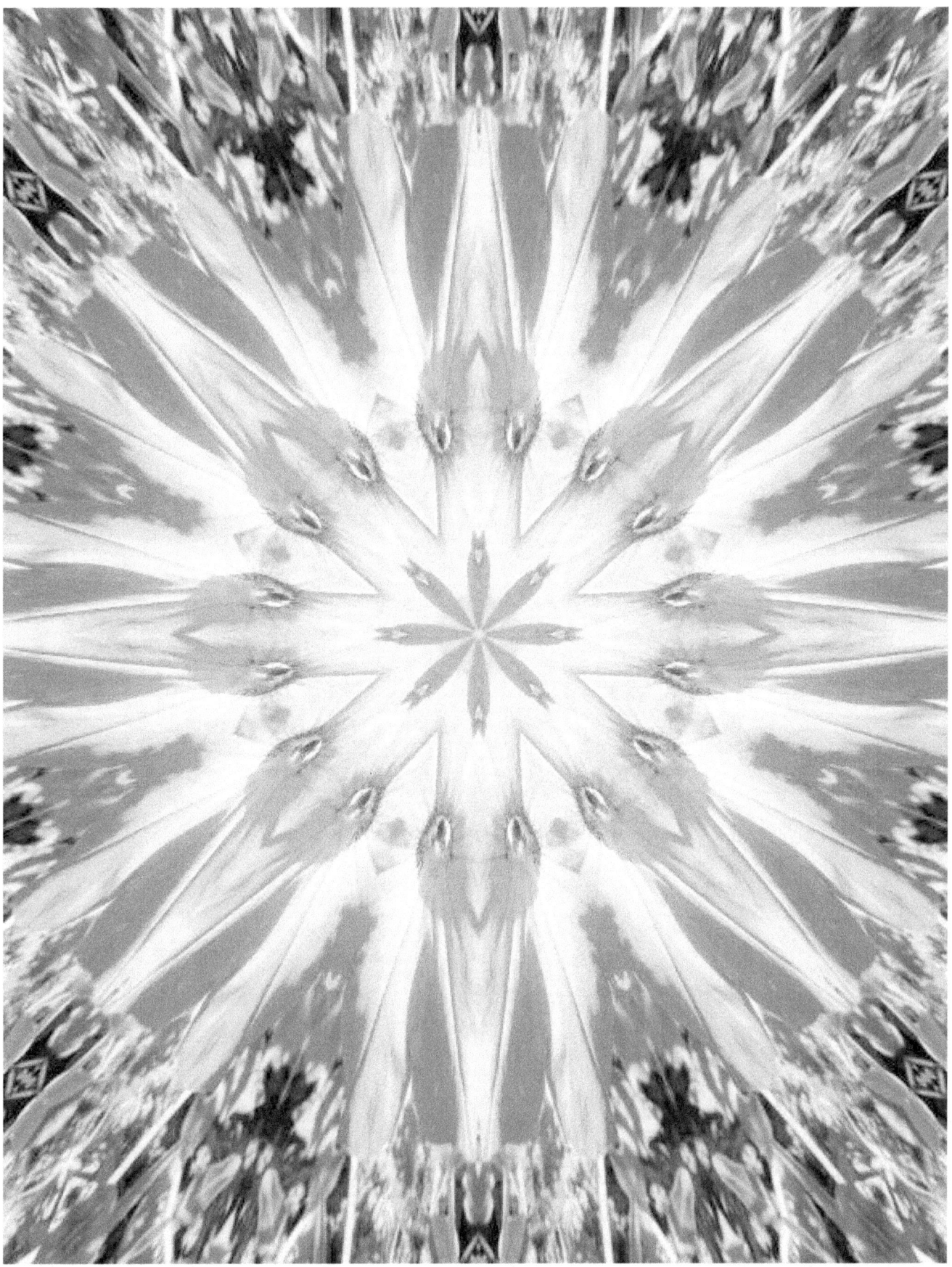

Petunias

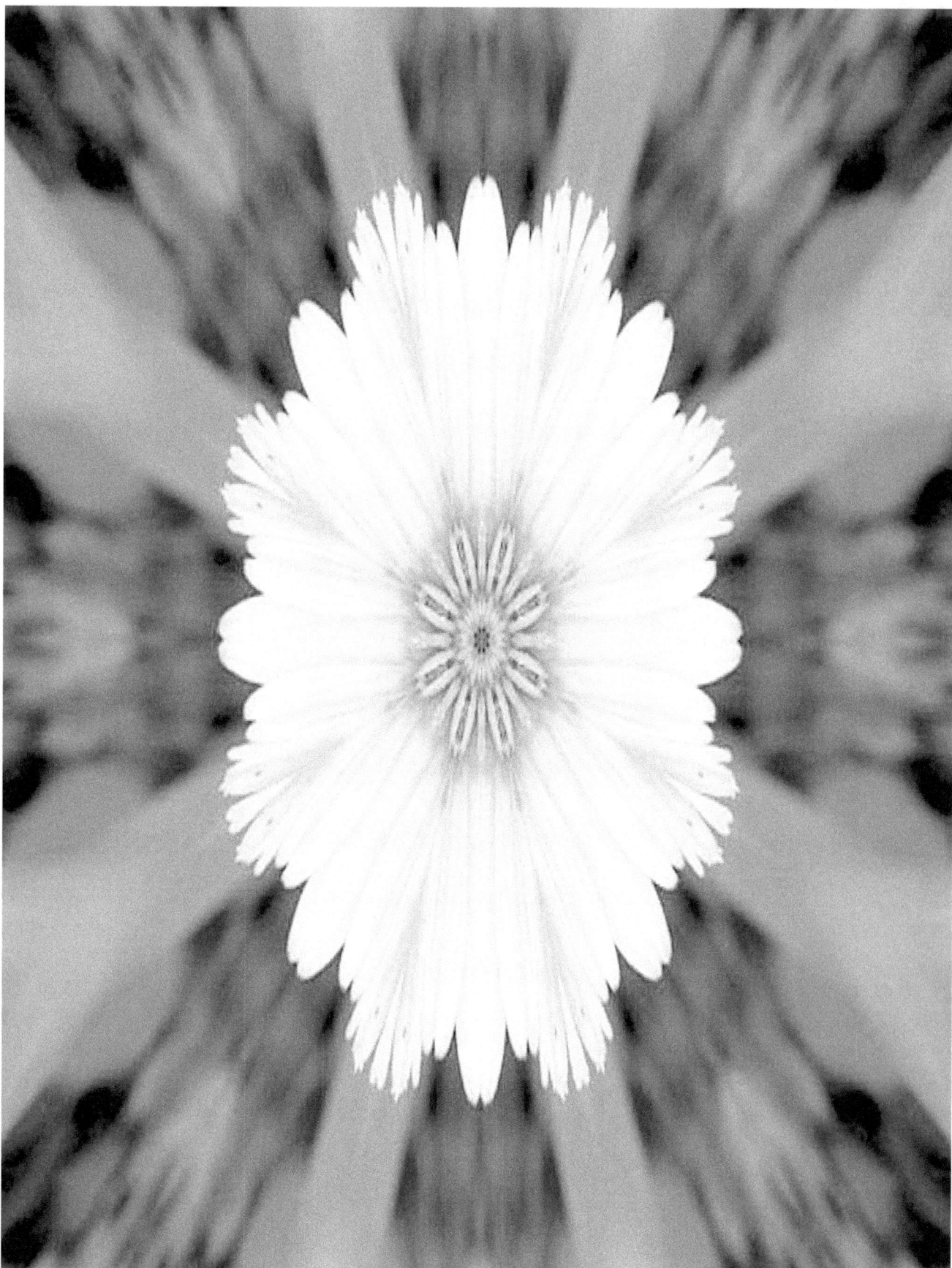

Zinnia

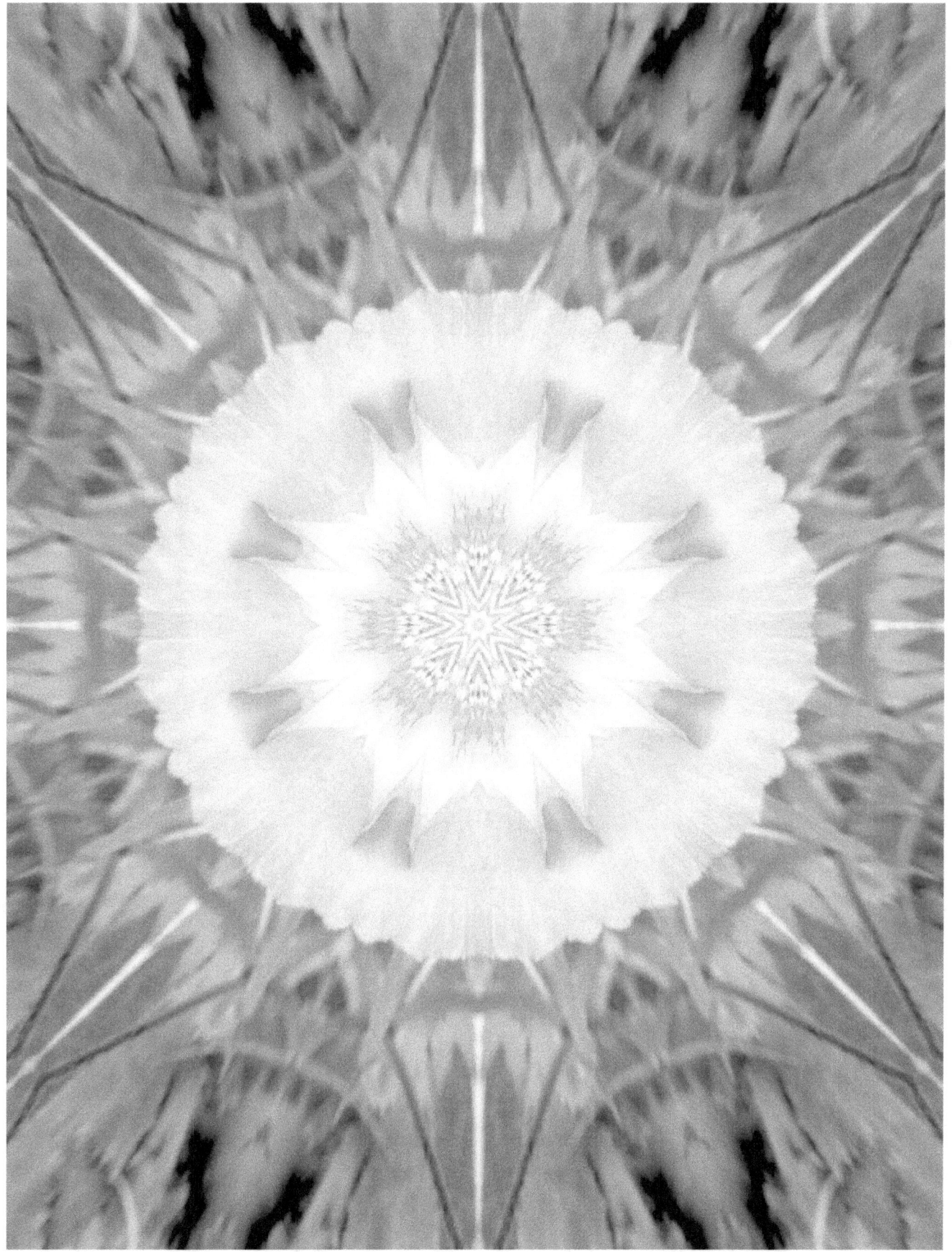

Poppy

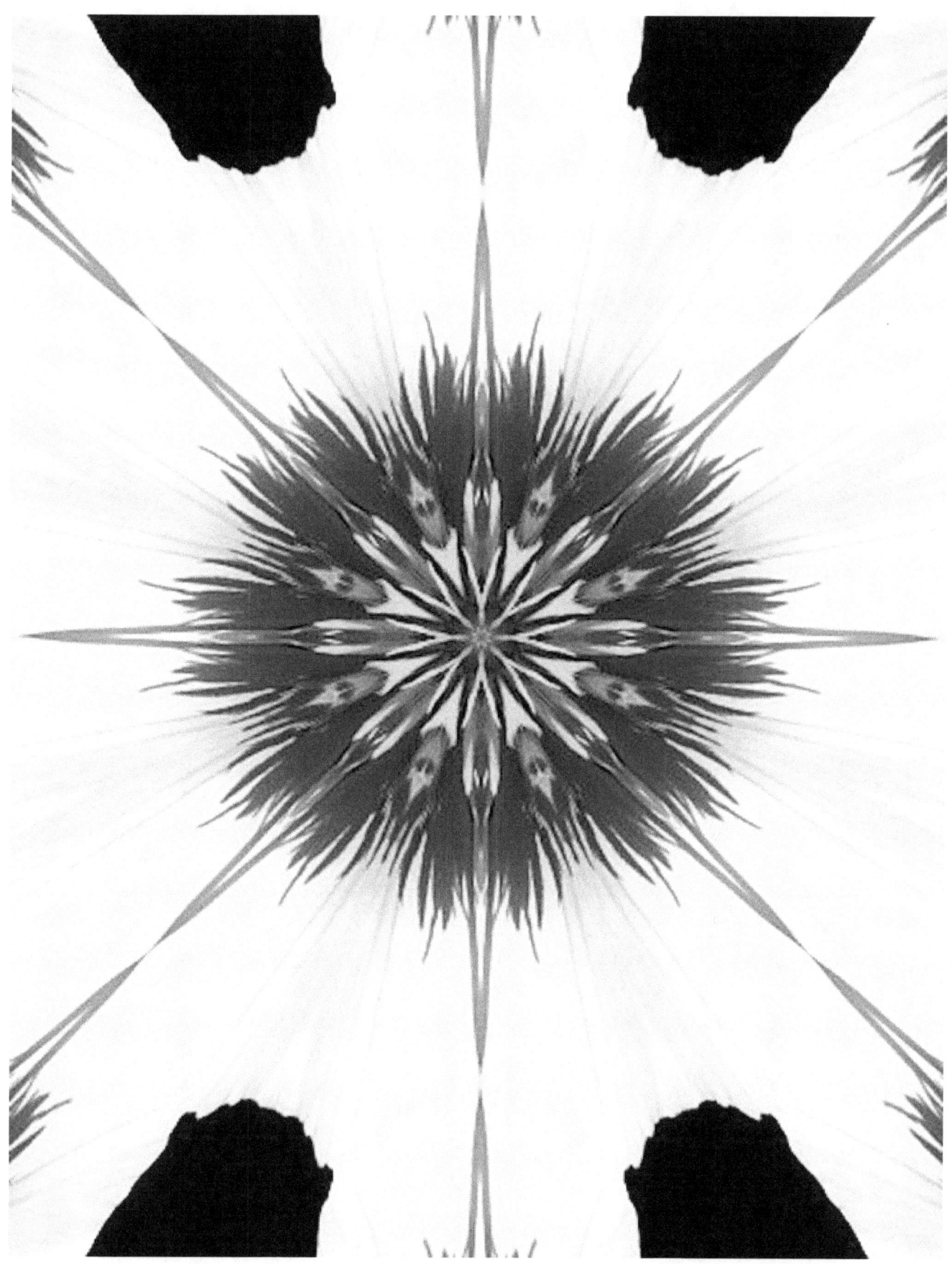

California Poppy

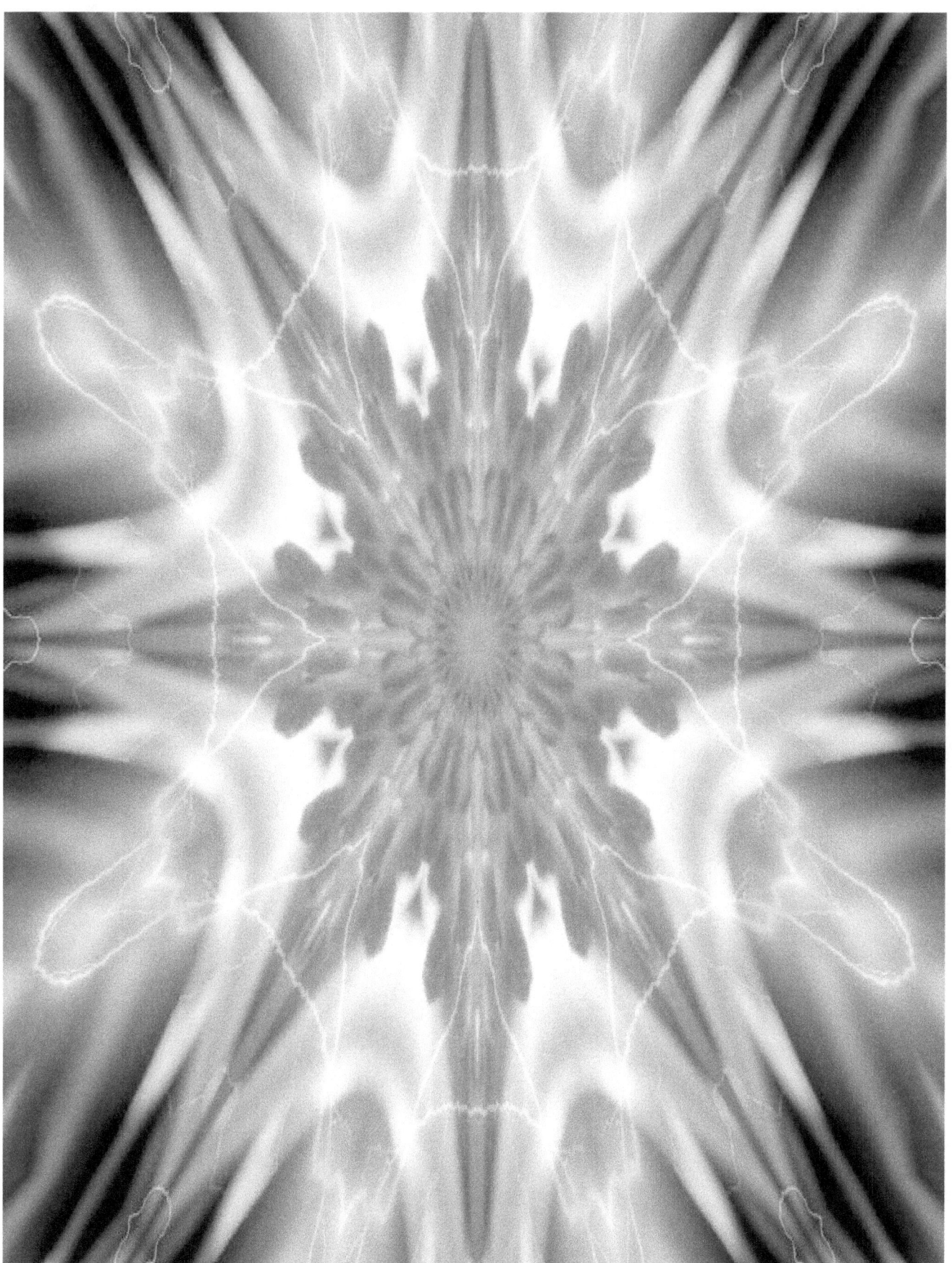

Portulaca

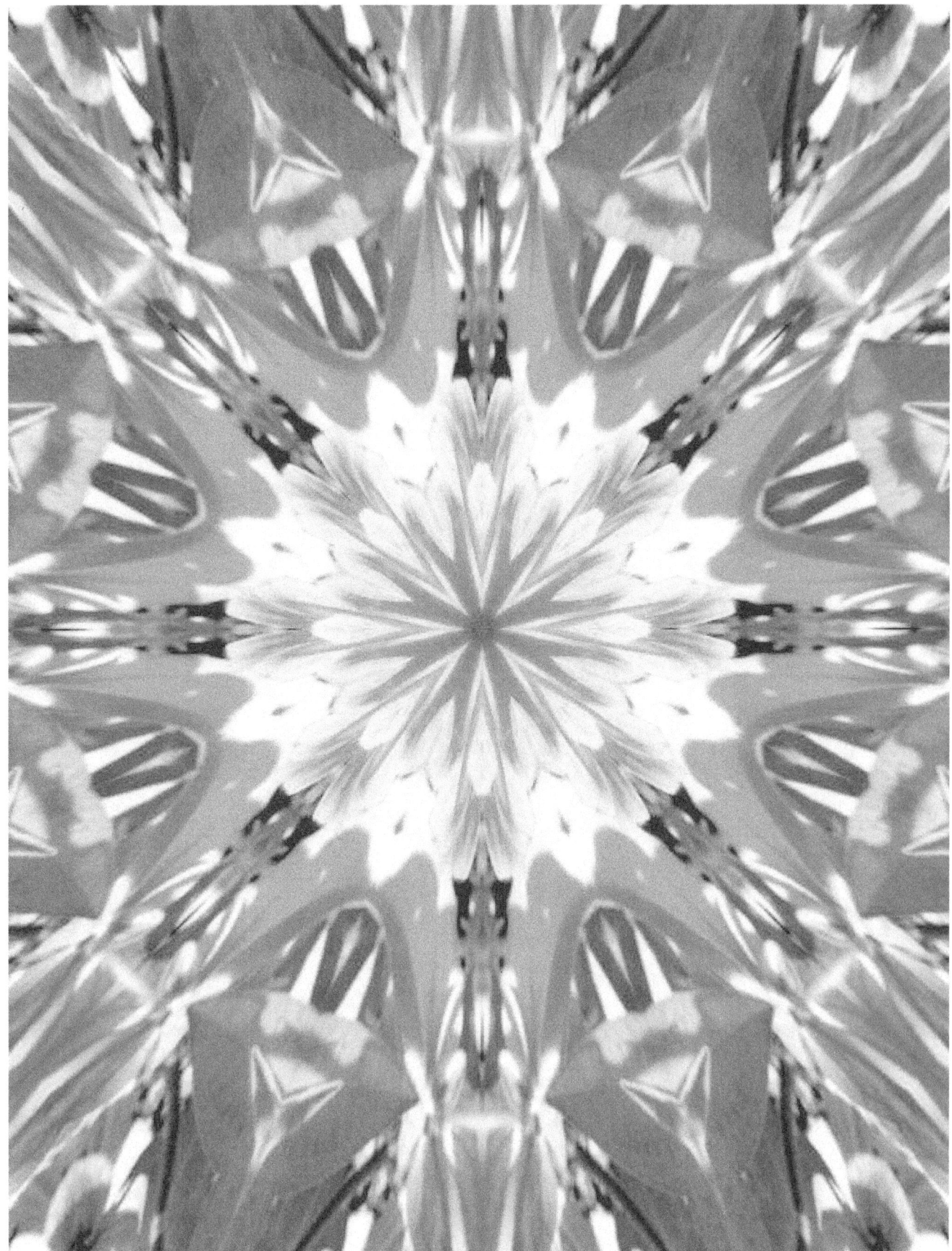

Zinnia

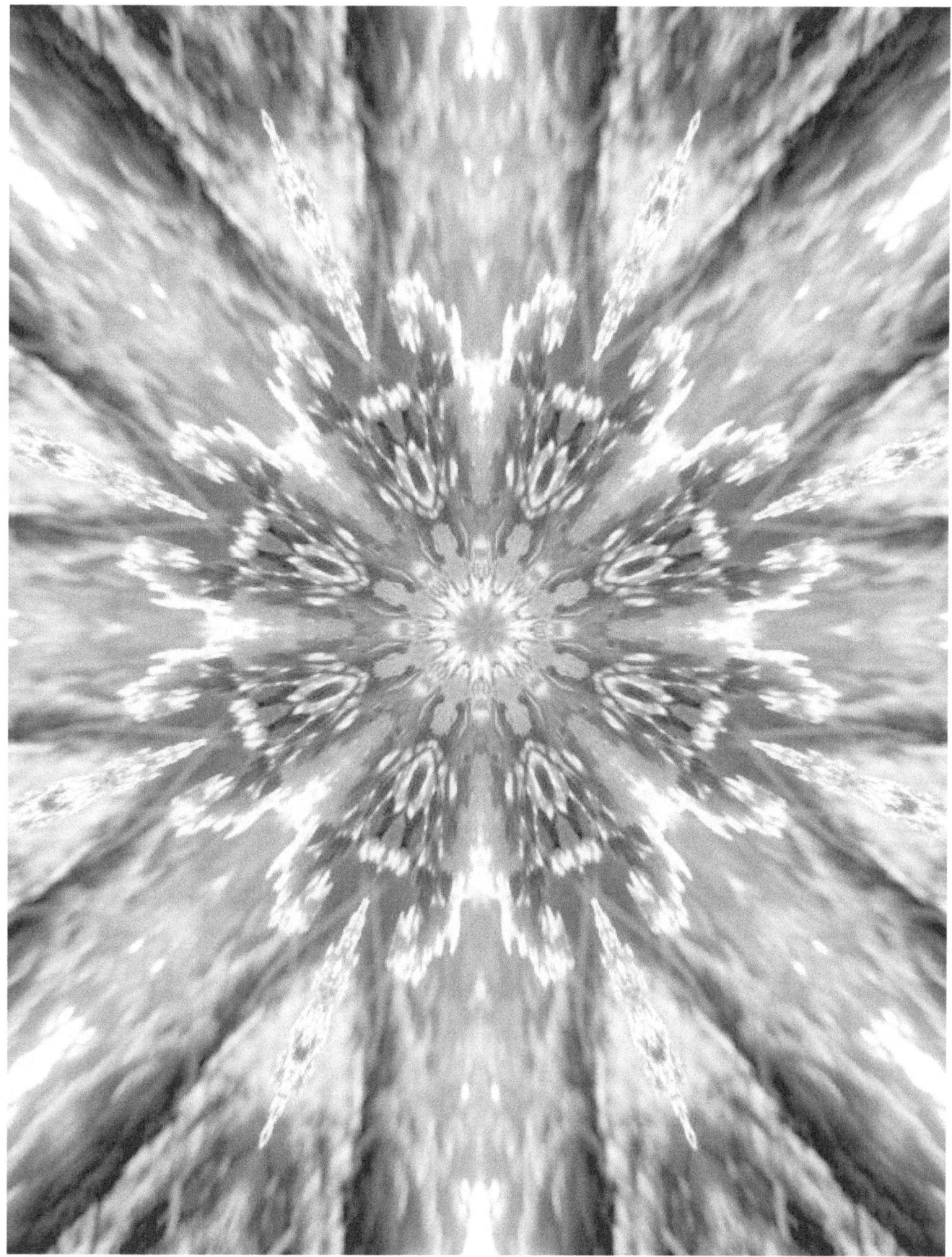

Myrtle

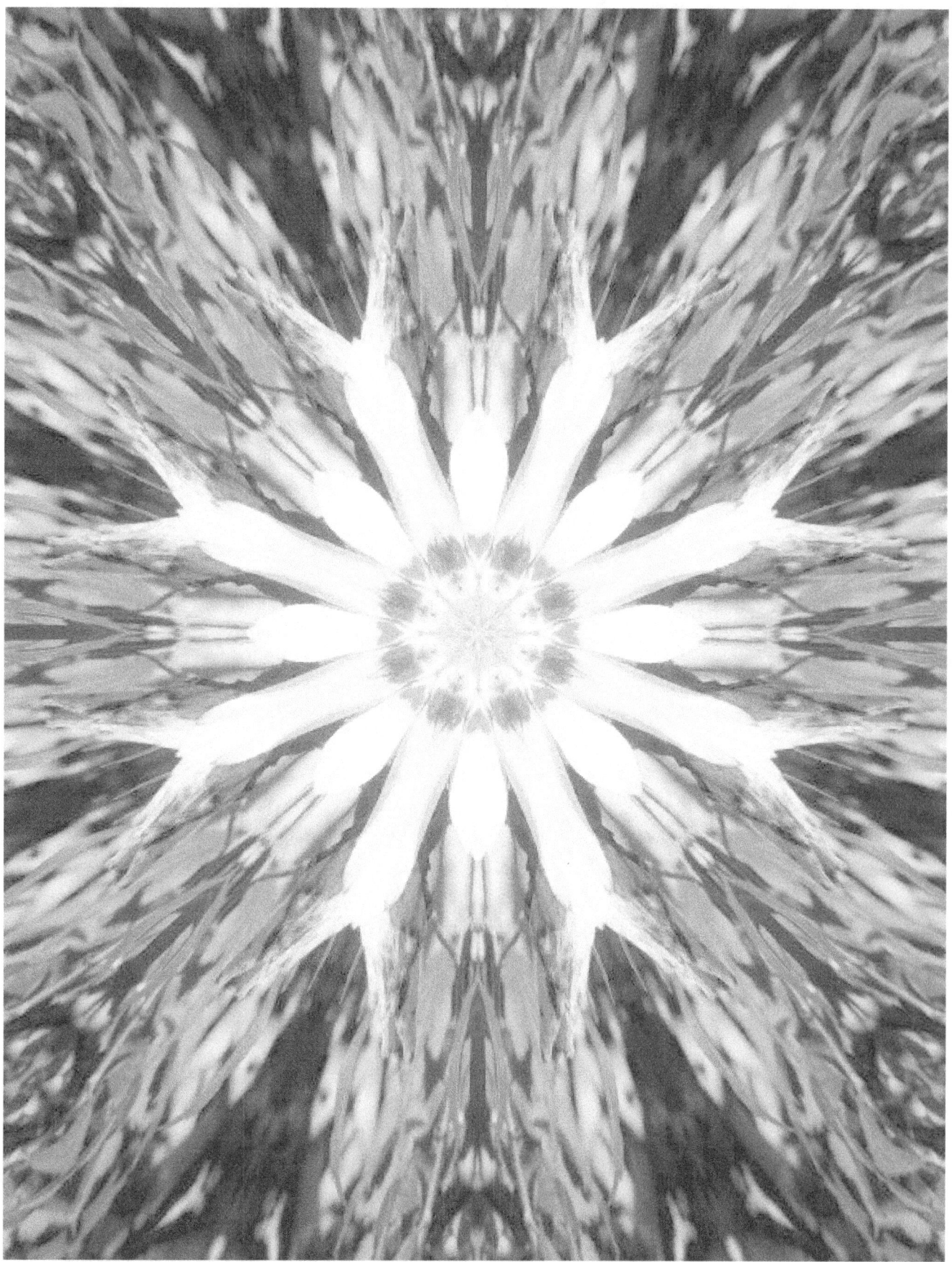

Rose of Sharon

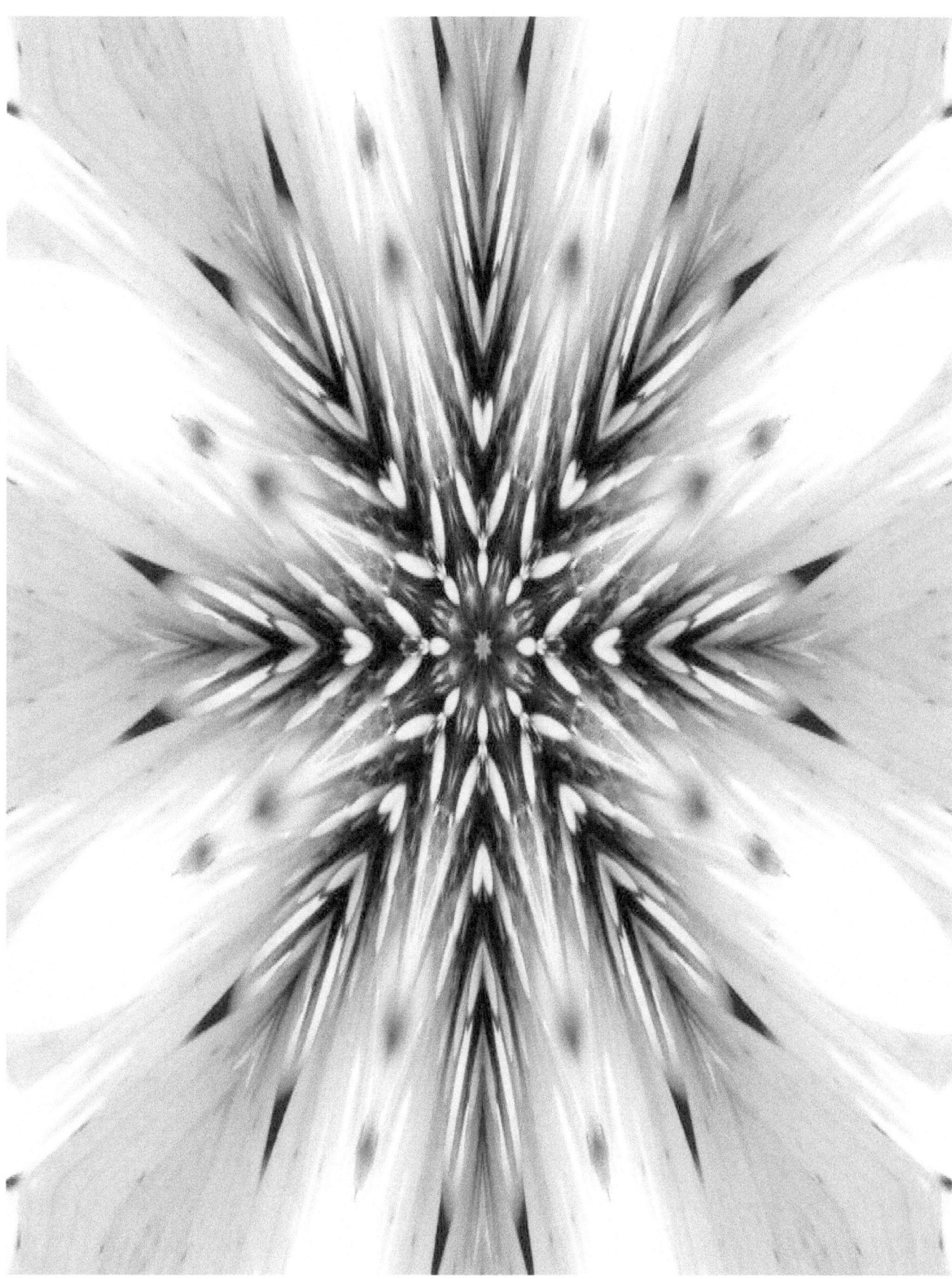

Coneflower

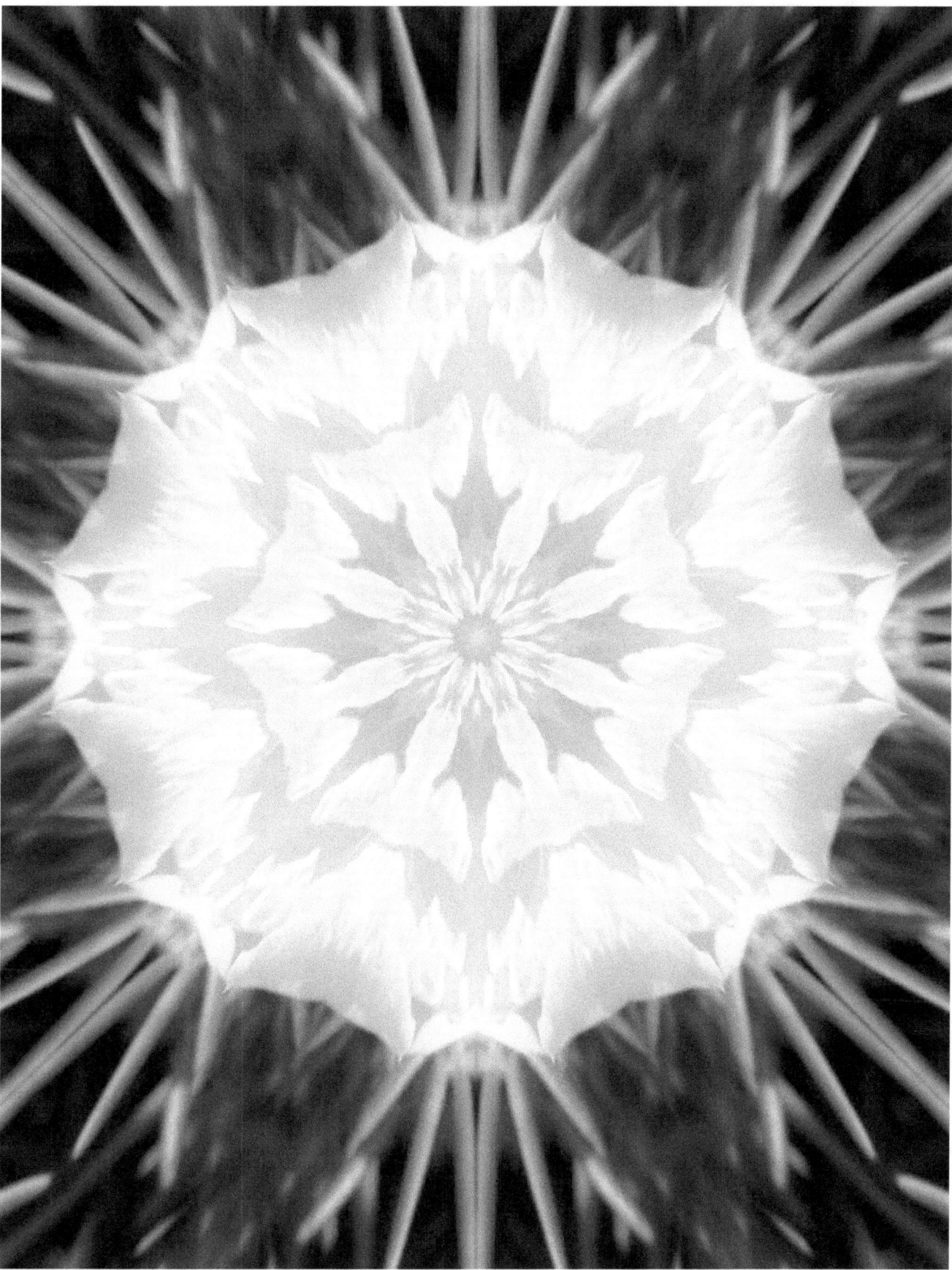

Portulaca

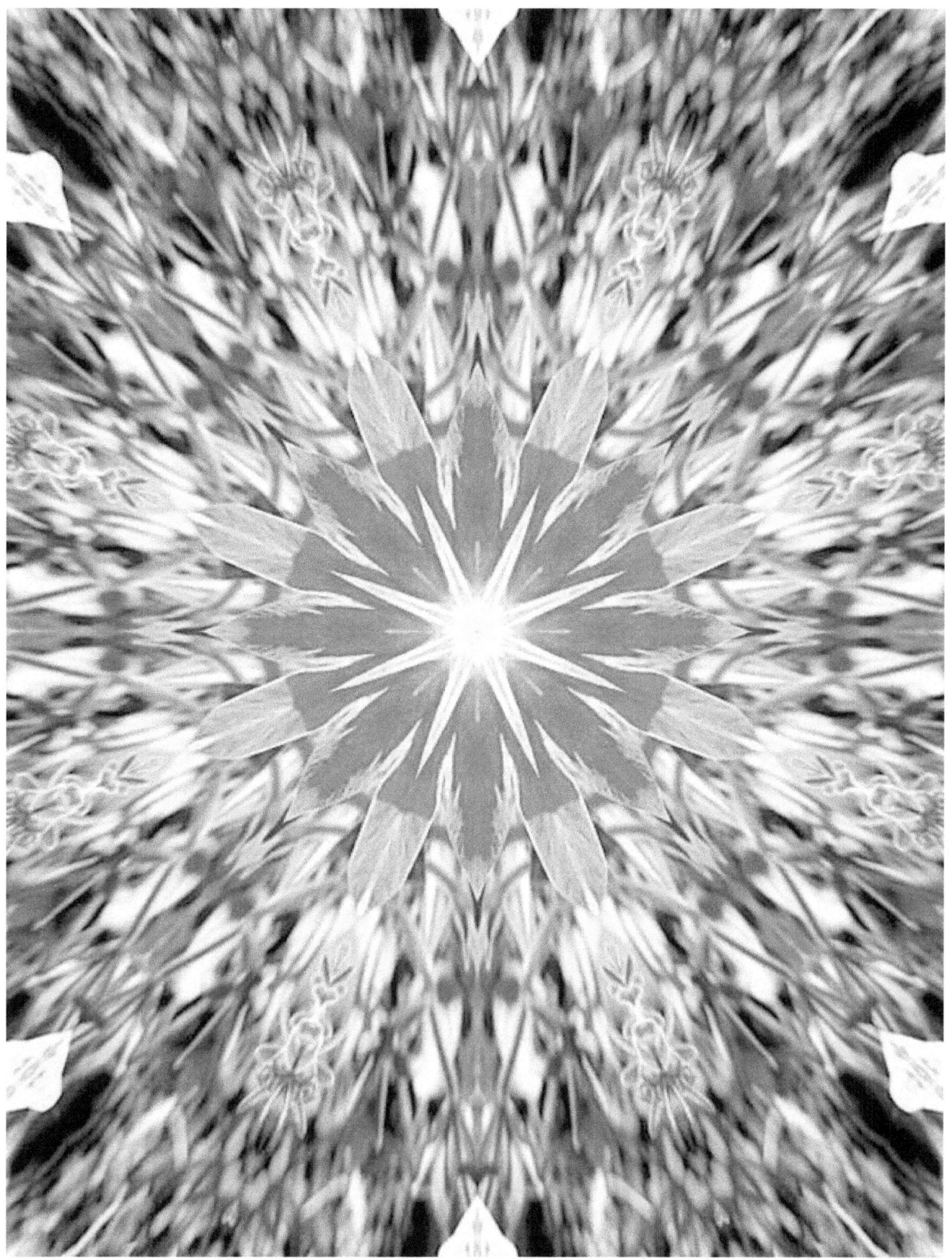

Sunny Petunia

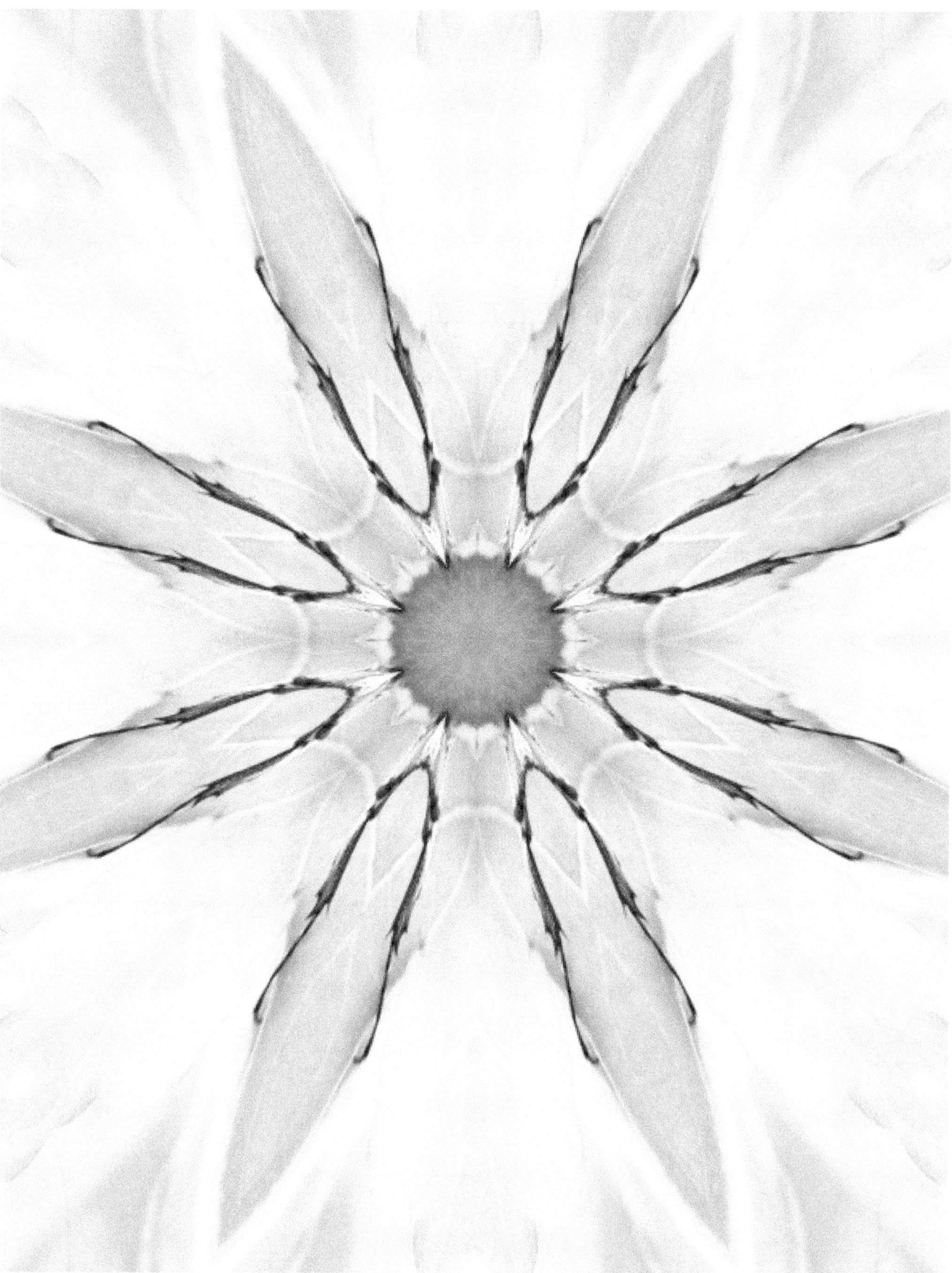

Rose of Sharon With Beautiful Green June Bug

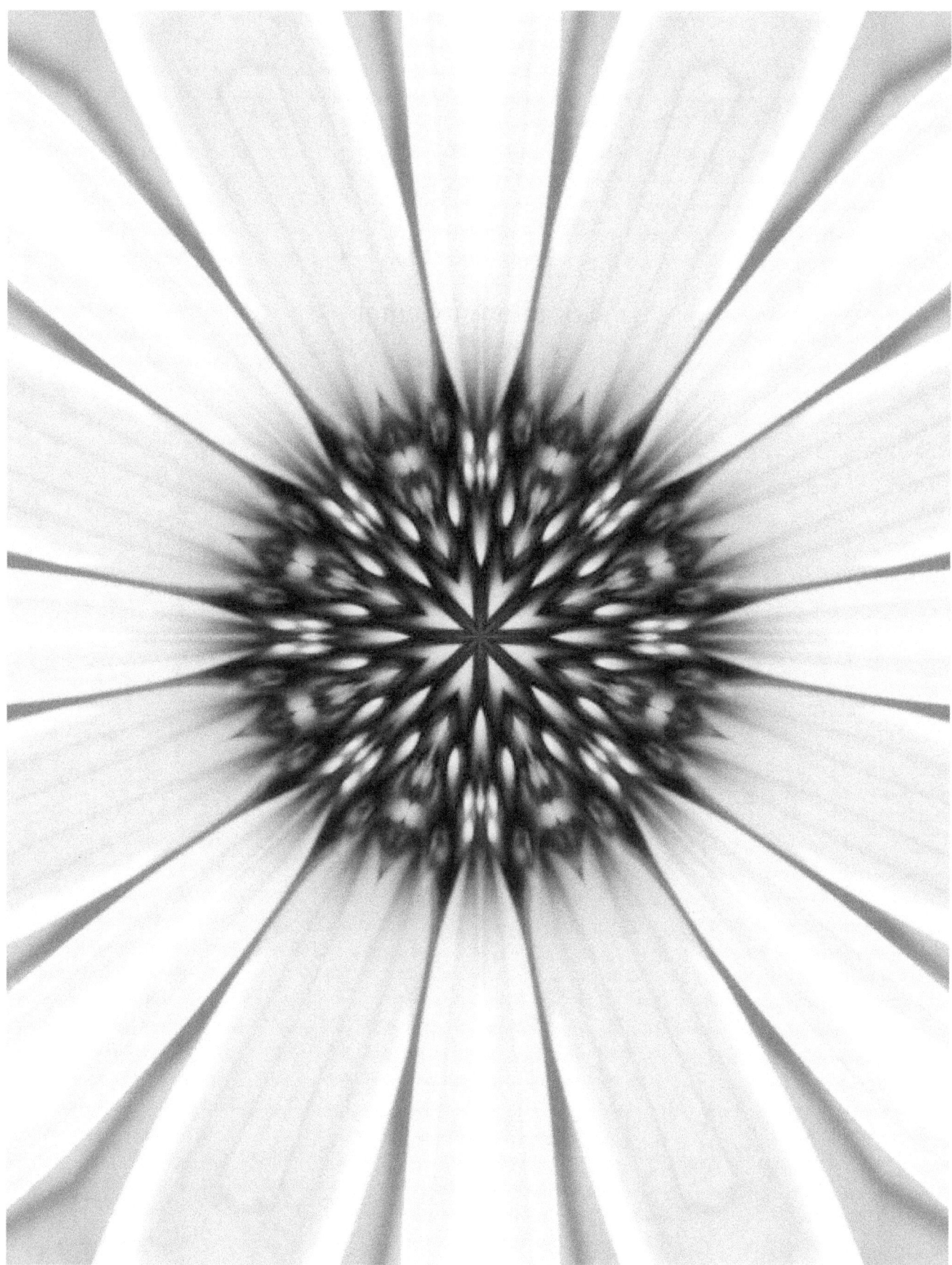

Coneflower Center
Feed The Bees

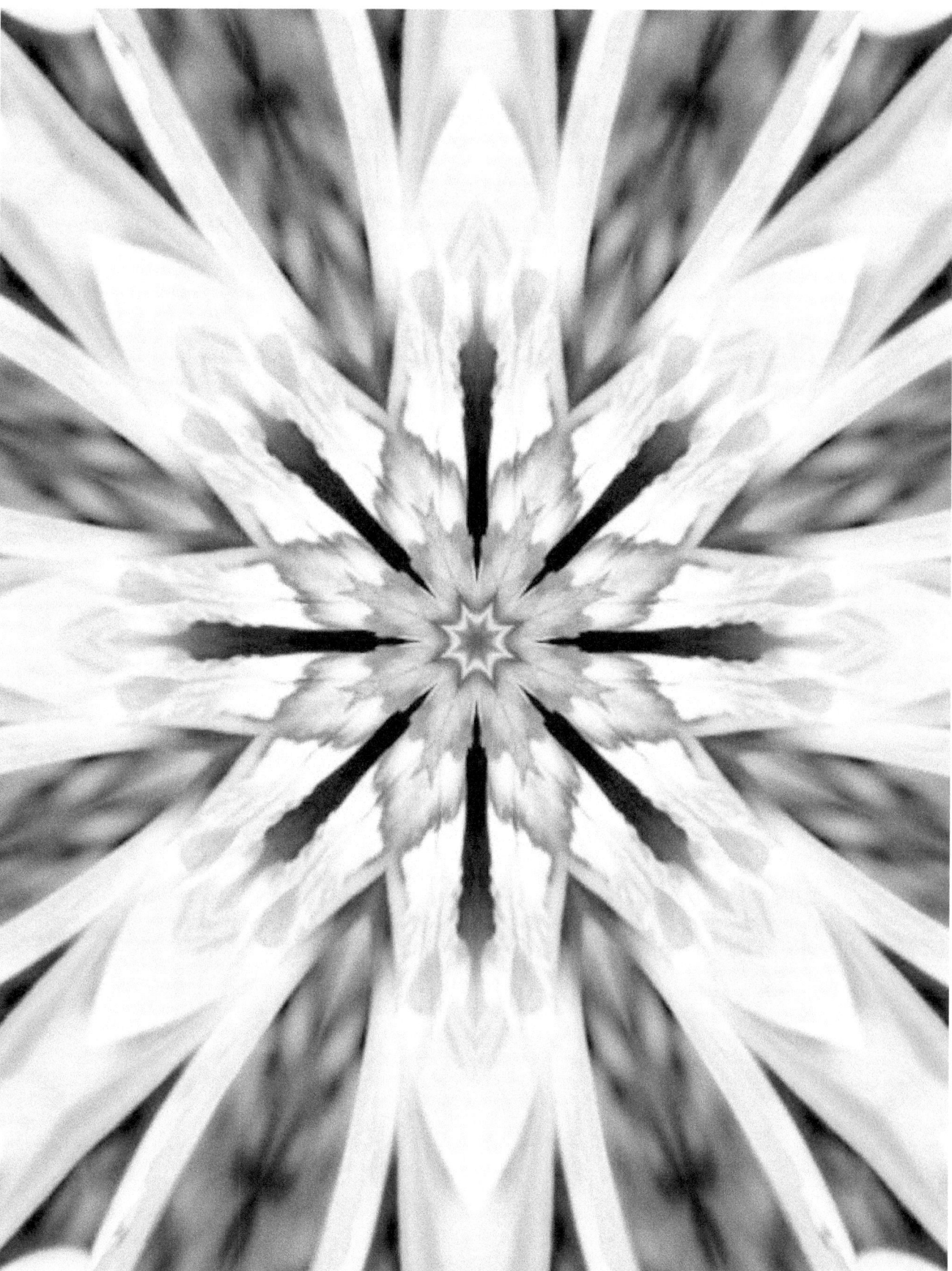

Dwarf Iris

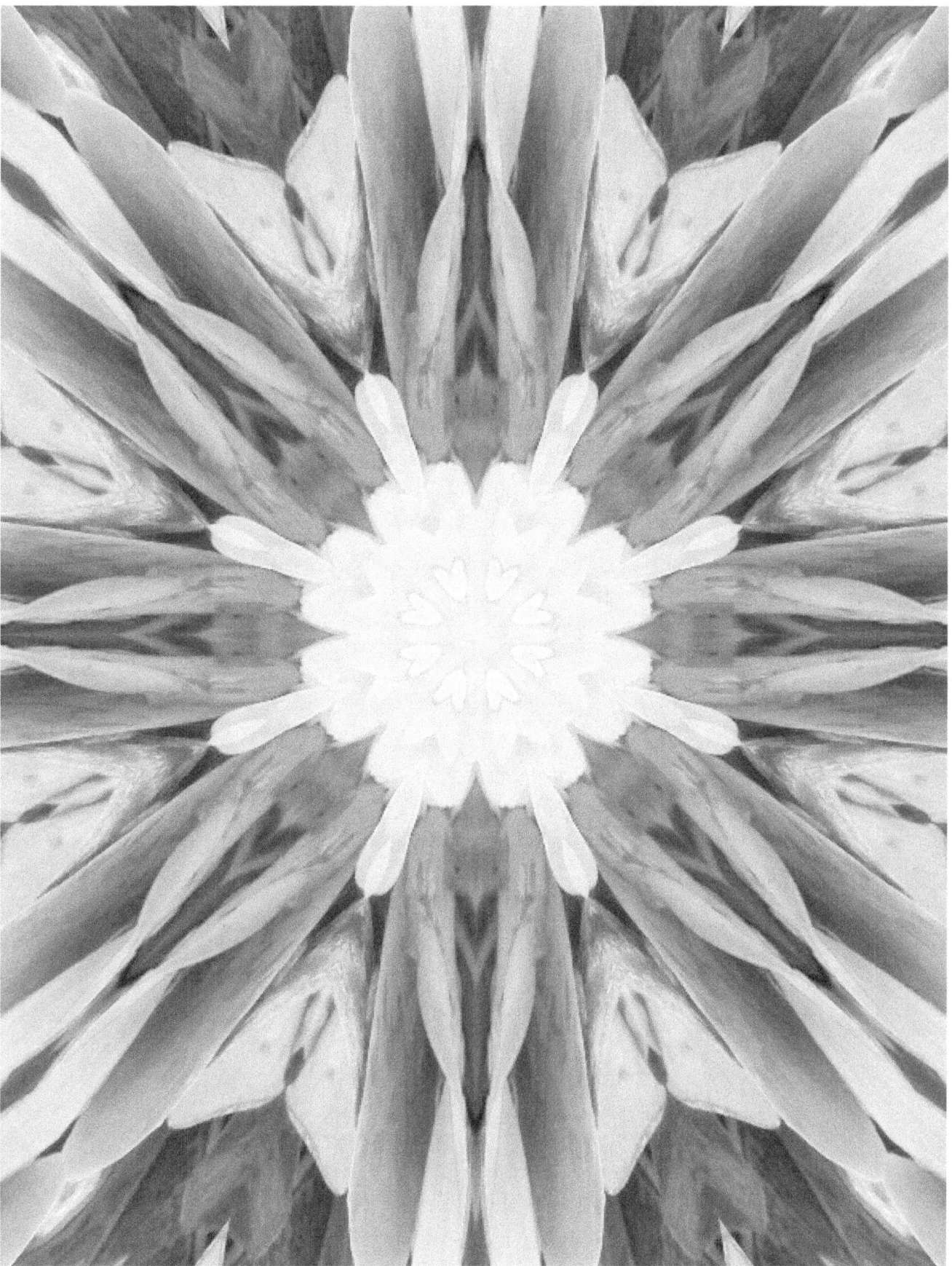

Mystery Flower
Bright Pink with two round petals and tiny yellow center

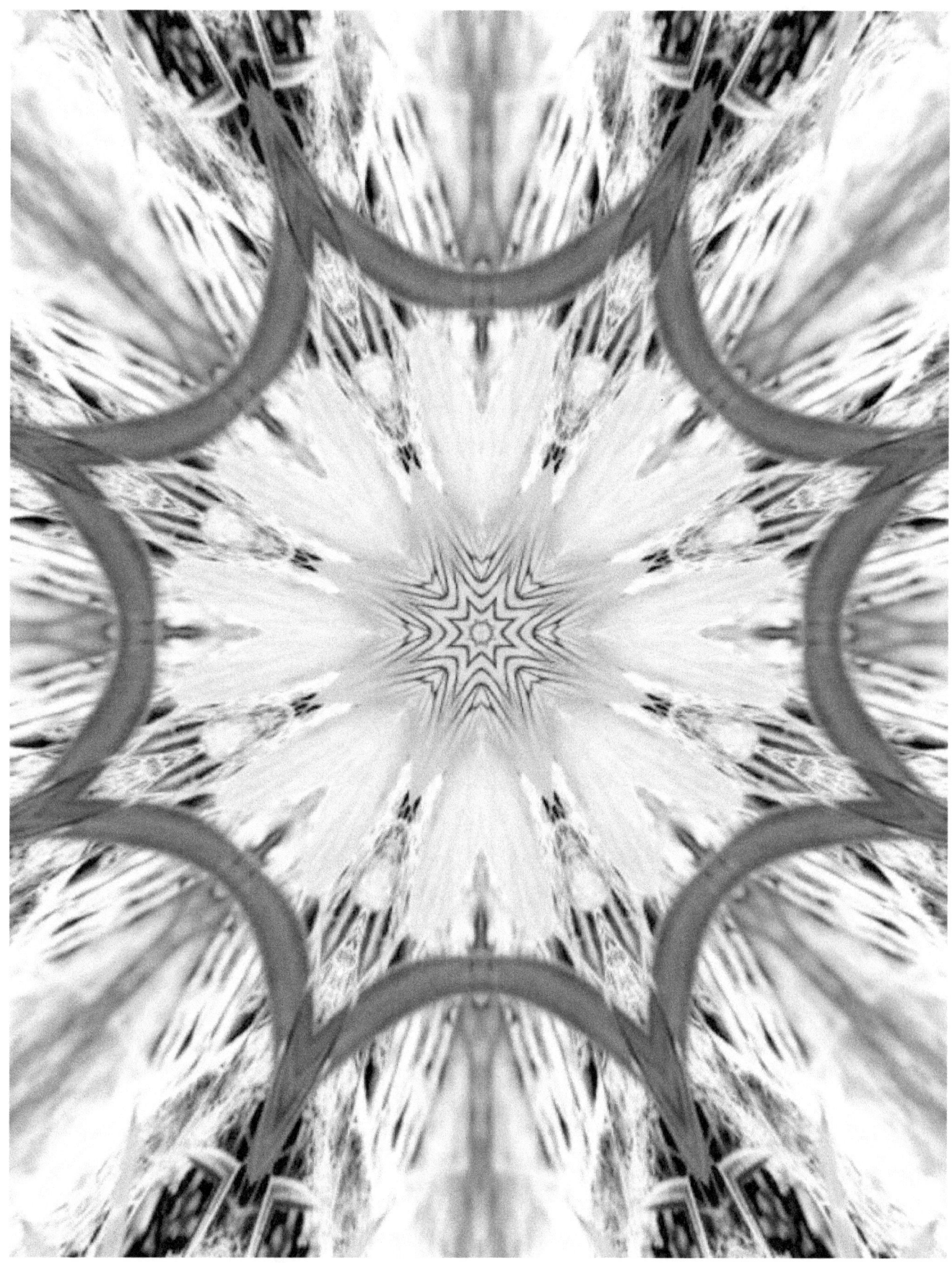

Wild Violets or Violas

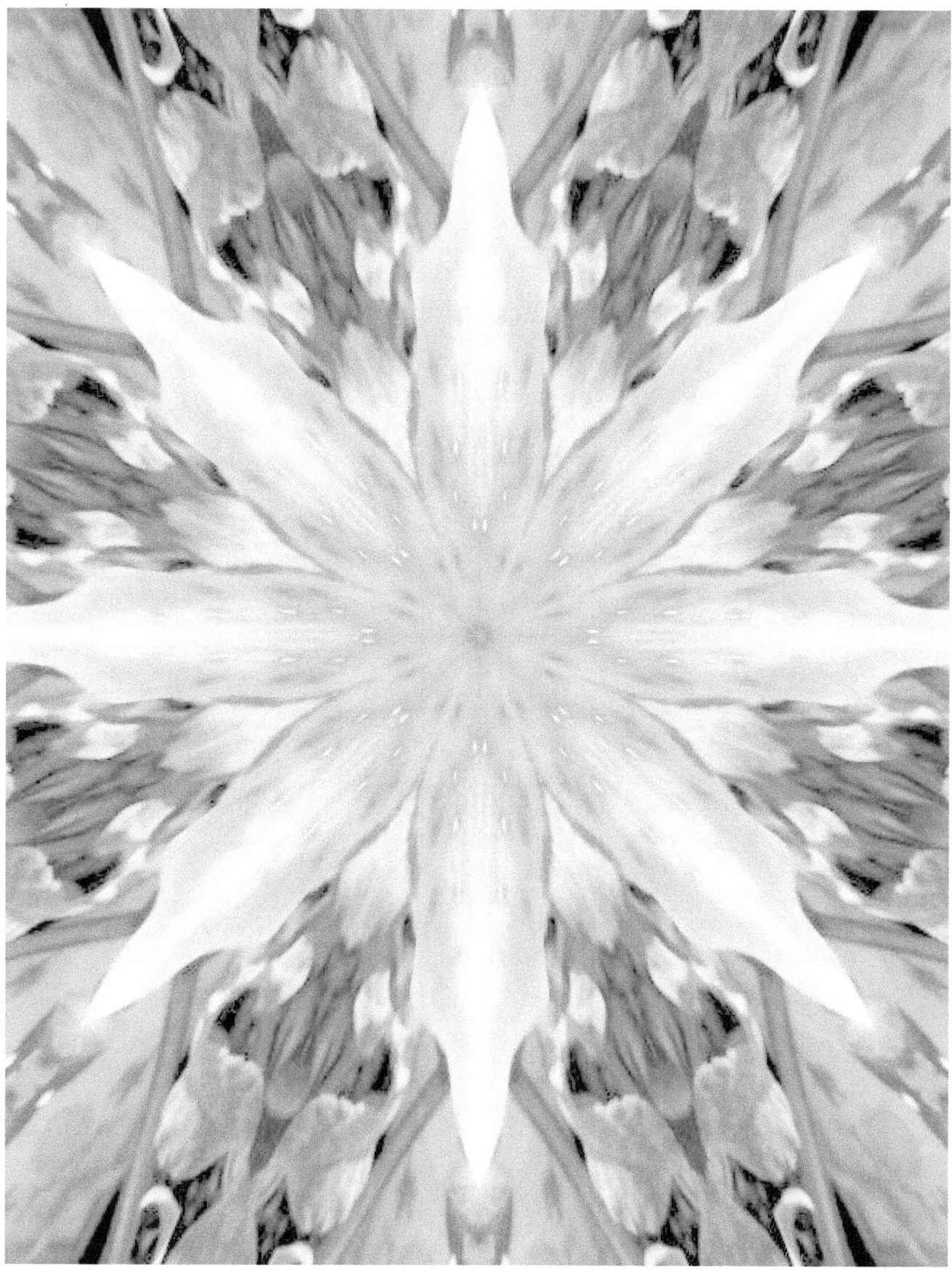

Asiatic Lily

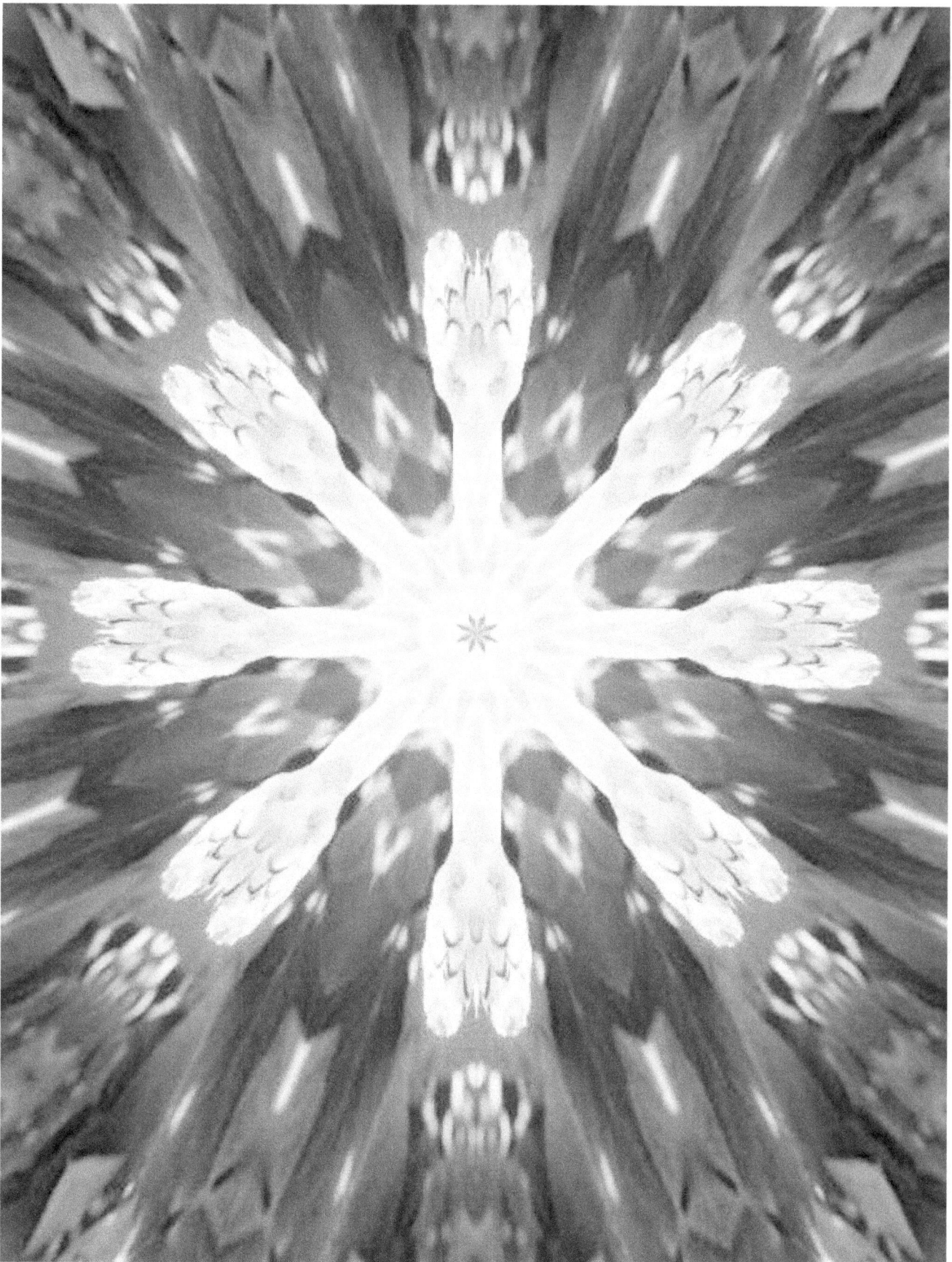

Zinnia Bud

ABOUT THE AUTHOR

Erika grew up with sand and sun in her hair in Narragansett, RI. Ever the adventurer and all around tiny animal finder, her interest in the small details and the humble parts of nature took hold.

She was set up on a blind date at 17-years-old where she found her husband. They raised three children in Groton, CT where their home was surrounded with woods and streams which helped nurture their kids' interest in nature.

Erika's background includes working as a CNA, MA(AAMA), and as a medical transcriptionist - which she enjoyed until she was replaced by a dragon.

Her continued love of nature, gardens, Beale Street Music Festival and her pets compels her to take far too many photos, some of which she would like to share.

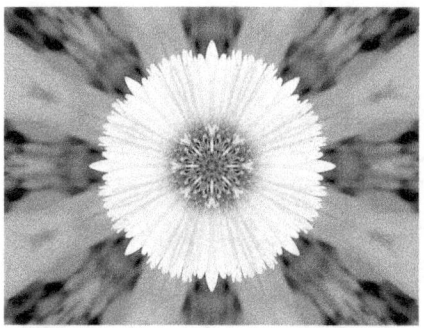

A Note On The Format Change

Although this is an On Kaleidoscope coloring book, the format has been changed to allow for larger prints and thus a larger book size has been used. Image quality had unwittingly been sacrificed through the cropping process and the colorist deserves the best pages to personalize. Hopefully the coloring experience will be more harmonious with this setup.

Thank You.

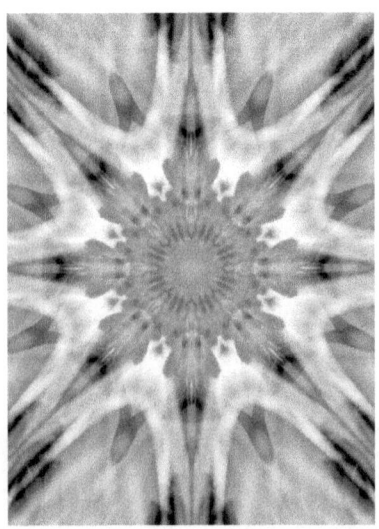
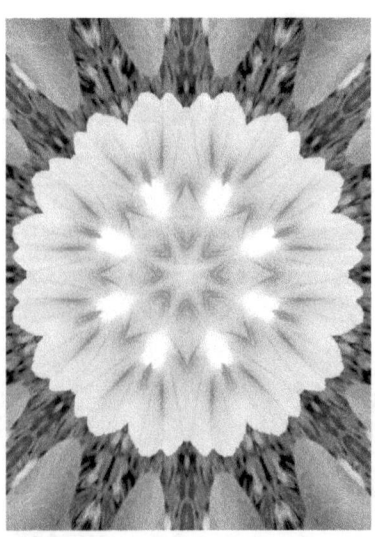
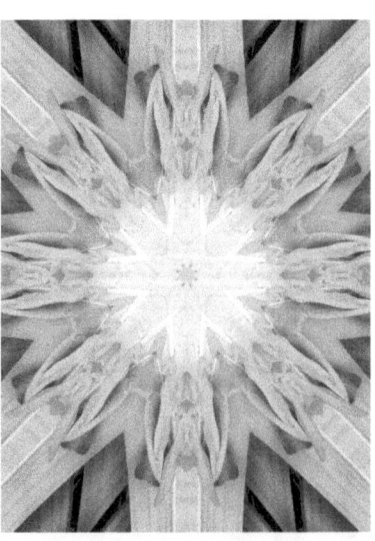

www.ingramcontent.com/pod-product-compliance
Lightning Source LLC
Chambersburg PA
CBHW080721190526
45169CB00006B/2467